IRONBRIDGE GORGE

GORGE

THROUGH TIME

John Powell

AMBERLEY PUBLISHING

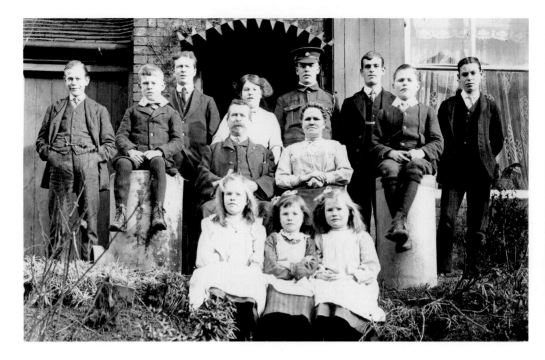

The Millward family of Wellington Road, Coalbrookdale.

First published 2009

Amberley Publishing Plc
Cirencester Road, Chalford,
Stroud, Gloucestershire, GL6 8PE

www.amberley-books.com

Copyright © John Powell, 2009

The right of John Powell to be identified as the
Author of this work has been asserted in accordance
with the Copyrights, Designs and Patents Act 1988.

ISBN 978 1 84868 671 7

All rights reserved. No part of this book may be
reprinted or reproduced or utilised in any form
or by any electronic, mechanical or other means,
now known or hereafter invented, including
photocopying and recording, or in any information
storage or retrieval system, without the permission
in writing from the Publishers.

British Library Cataloguing in Publication Data.
A catalogue record for this book is available from
the British Library.

Typeset in 9.5pt on 12pt Celeste.
Typesetting by Amberley Publishing.
Printed in the UK.

Introduction

As time passes, it becomes increasingly difficult to visualise the Ironbridge Gorge as it once was. During the past thirty to forty years, tree growth has gone largely unchecked, resulting in a covering of lush green foliage to be seen everywhere during the summer months. The River Severn, when not in spate, runs comparatively clear and unpolluted. There is no acrid blue smoke rising from cupolas, nor other unpleasant industrial smells hanging in the air. Wildlife abounds, with rare orchids and strange fungi to be discovered alongside footpaths, and herons, kingfishers and even otters to be glimpsed at the water's edge.

It was not always like this. As early as 1776 one visitor noted the contrast between the picturesque hanging woods on the upper slopes and 'that variety of horrors art has spread along at the bottom: the noise of the forges, mills, etc with all their vast machinery, the flames bursting from the furnaces with the burning of the coal and the smoak of the lime kilns...' Within a few years, the landscape of the Gorge and its surrounding area, then known collectively as Coalbrookdale, was totally transformed, becoming one of the first places anywhere to experience the full ravages of the Industrial Revolution. By the late eighteenth and early nineteenth centuries the whole locality was a scene of frenzied activity and technological innovation, the like of which had never been seen before.

When the first photographers arrived on the scene, in the mid-1850s, the region's period of predominance was already over. Nevertheless, there were things to record which had changed little since this momentous time, such as the pools which had powered the furnaces and forges in Coalbrookdale, and the sailing trows on the River Severn, soon to lose their trade to the advancing railways. The Coalbrookdale Company employed a photographer at their works from at least 1855, so it is possible that he took some of these priceless early topographical views. As the century progressed, other photographers were on hand to capture what was, despite the relative prosperity of the brick and

tile industries, a time of slow, painful decline which continued right up until the Second World War. It is on record that, by this time, Ironbridge was such a run-down and depressing place that many locals would go out of their way to avoid it.

Since the 1950s the area's fortunes have been dramatically revived. A growing interest in 'industrial archaeology' began to attract visitors, and a small museum was opened in Coalbrookdale by Allied Ironfounders Ltd in 1959. The Ironbridge Gorge Museum Trust was established in 1967 to care for the key industrial monuments and sites, and 'heritage tourism' became increasingly popular. In 1986, in recognition of its universal historic importance, the Gorge was designated by UNESCO as a World Heritage Site and is now widely regarded as an exemplar of successful regeneration.

The historic photographs in this volume have been drawn exclusively from the collection held in the library of the Ironbridge Gorge Museum Trust, to whom they were generously donated or lent for copying by local residents. The selection is a purely personal one. Many of those chosen have appeared in print before, though some have not. They are arranged in geographical order, starting at the northern end of Coalbrookdale and progressing southwards towards Dale End. From here, there is a detour to Buildwas, before continuing from west to east as far as Coalport Bridge.

The modern photographs have all been taken by the author over the last thirty years, usually when he was on foot or on a bicycle. These are the recommended modes of transport for those who will hopefully be inspired to visit for the first time or further explore this truly fascinating place.

John Powell

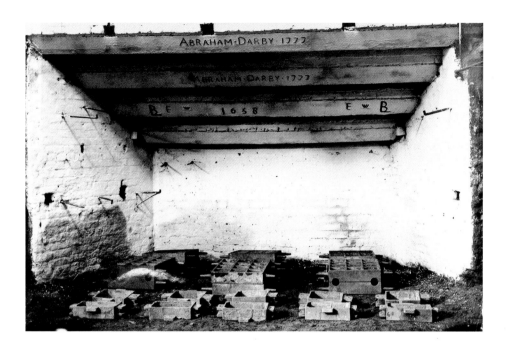

Old Furnace, Coalbrookdale

The Old Furnace in Coalbrookdale, where the first Abraham Darby made his great breakthrough in 1709, had become the rear wall of a mundane workshop by the late nineteenth century. Later on, corrosion due to years of exposure to the elements caused the date 1658 to be incorrectly 'restored' as 1638, resulting in much confusion among historians!

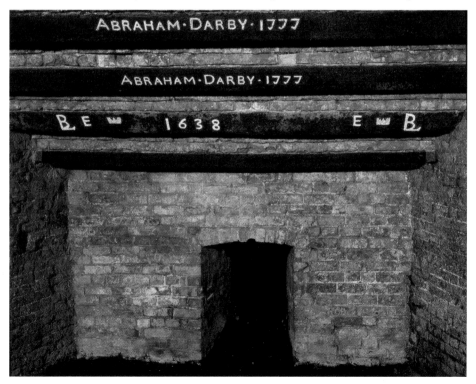

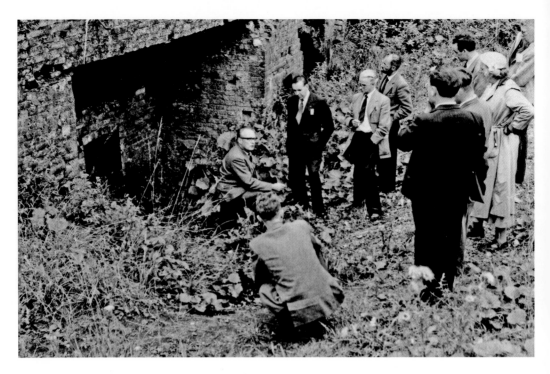

Taking a Closer Look

Visitors in the early 1950s, complete with tweed sports jackets and ties, had to scramble across wasteland and undergrowth to take a closer look at the Old Furnace. Since 1982, it has been protected by a modern Cover Building, making it a much more pleasant experience for today's visitor. Note the changes in leisurewear!

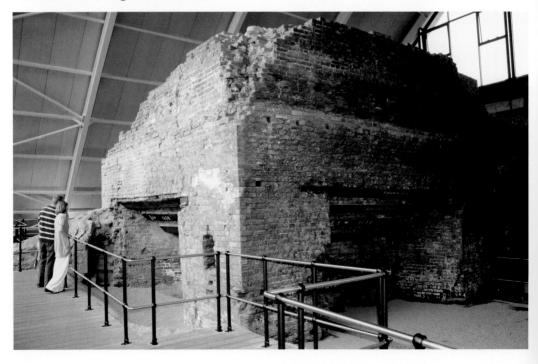

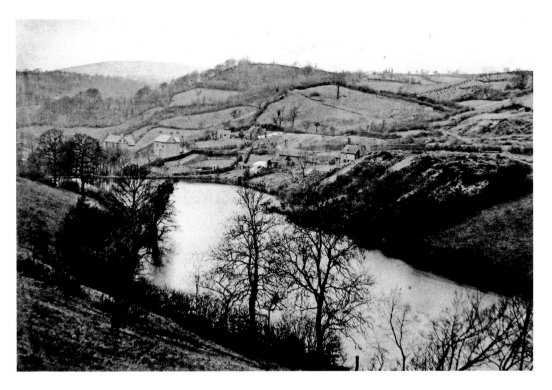

New Pool

This was the uppermost of six pools feeding the water system which powered numerous waterwheels in Coalbrookdale. Its name is misleading, as it actually dates from the late seventeenth century. When the railway was built, it was reduced to half its former size, requiring a substantial retaining wall between pool and railway.

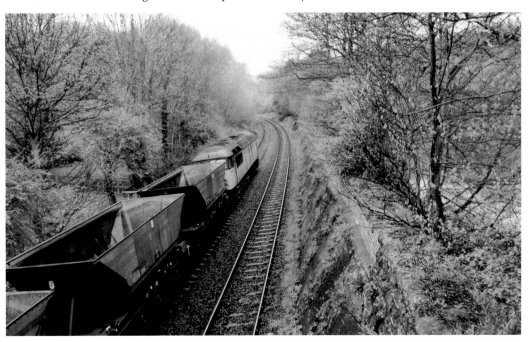

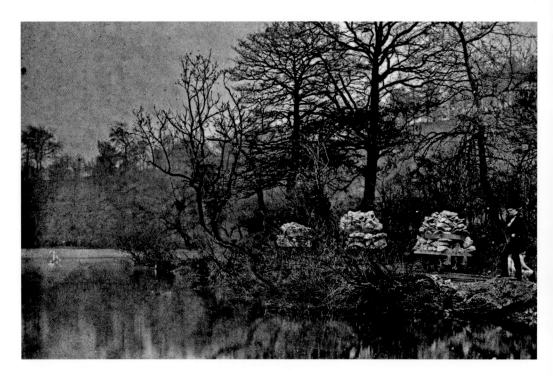

Early Plateway

Despite its poor quality, this photograph is of great significance. It is thought to date from about 1856 and is the only known view of one of the many plateways which once criss-crossed the area actually in operation. The limestone is held on the wagons by hoops of wrought iron. The route of this plateway now forms a delightful traffic-free footpath and cycle path between Coalbrookdale and Rough Park.

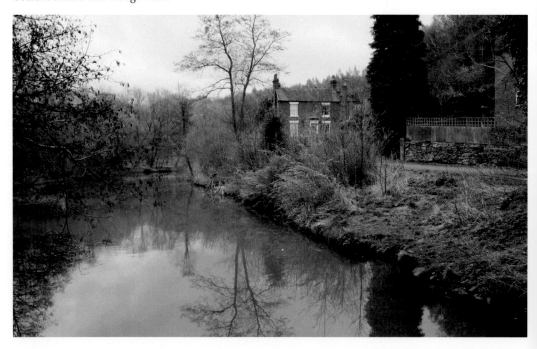

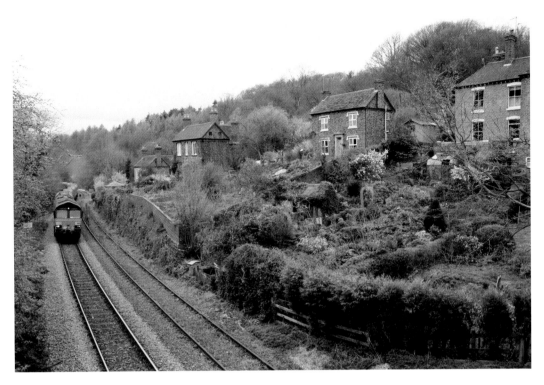

Cherry Tree Hill

The houses in Cherry Tree Hill are instantly recognisable from the older photograph, taken in 1863 or 1864, when the railway was still under construction. Details of the mine on the left have proved hard to come by, but a very large hole suddenly appeared in the woods hereabouts in 2009.

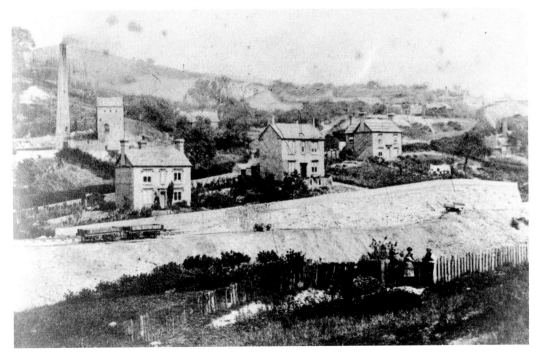

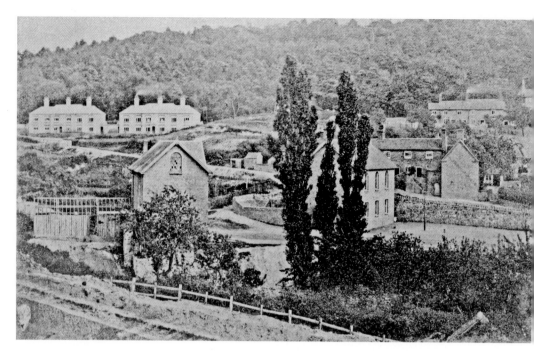

Coalbrookdale Mill

A view from the recently-completed railway across the area of Coalbrookdale known as Woodside. To the left is the water-powered corn mill, in use until the 1870s and, behind the poplars, the boys' school of 1840. Both were provided by the Coalbrookdale Company, and today survive as private residences. The new houses in the distance were built to replace some demolished by the railway company.

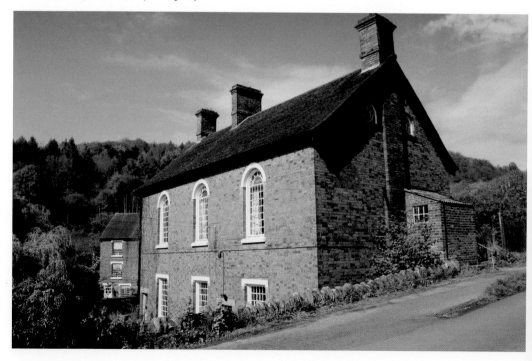

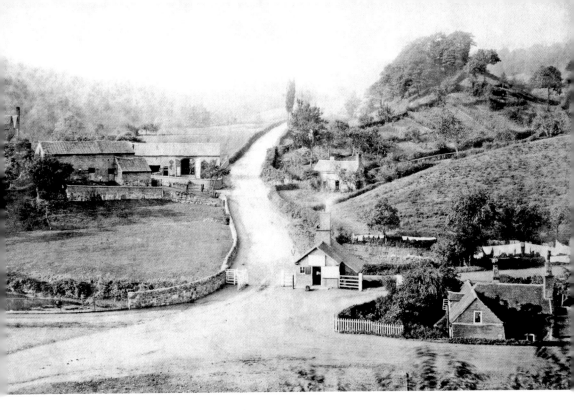

Coalbrookdale to Wellington Turnpike

The road between Coalbrookdale and Wellington was not turnpiked until the comparatively late date of 1818. This view shows the tollhouse, which formerly stood at the foot of Jiggers Bank, which must have been a formidable climb for a heavy horse-drawn vehicle.

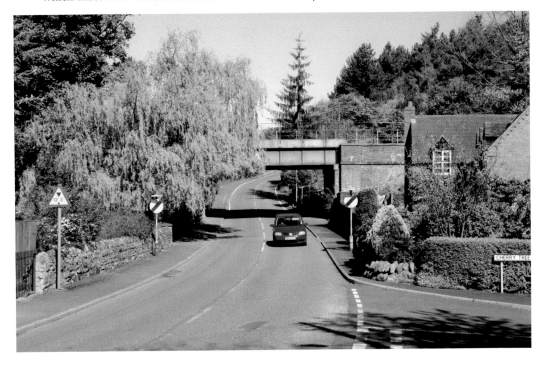

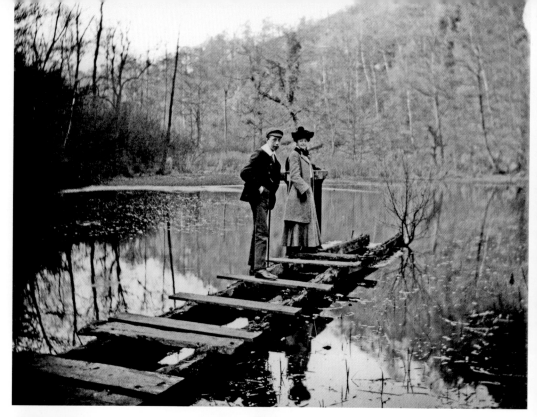

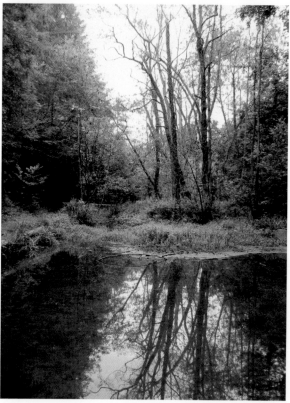

Lum Hole Dingle

The name may not sound terribly romantic, but this is a beautiful spot where the Lyde Brook flows down into Coalbrookdale from the direction of Little Wenlock. It was a popular venue for picnics in Victorian times. Today there is a well-maintained footpath, which is well worth exploring. If you are lucky, you may see a kingfisher or a dipper, as well as dragonflies and water plants in profusion.

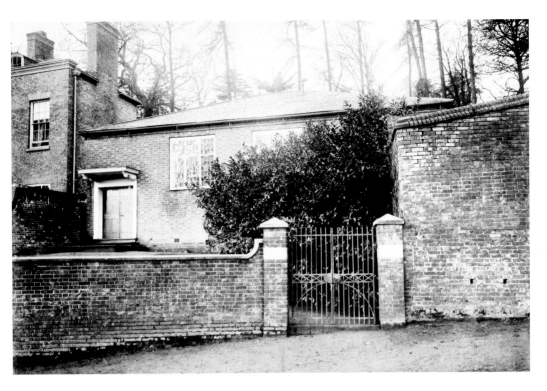

Quaker Meeting House

The early generations of Darbys and other ironmasters were staunch Quakers. This was the second Quaker Meeting House in Coalbrookdale, dating from 1808, and replaced an earlier one at the south end of Teakettle Row. It was used to house evacuees during the Second World War but, unfortunately, was demolished shortly afterwards; however, the adjacent Quaker Burial Ground survives.

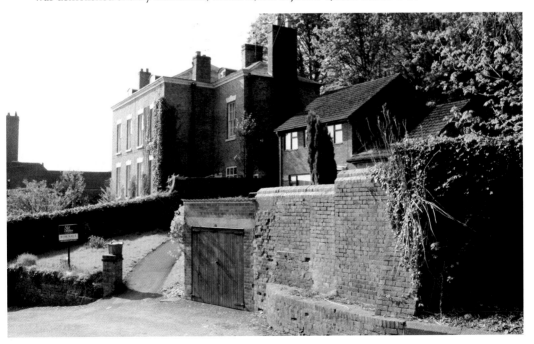

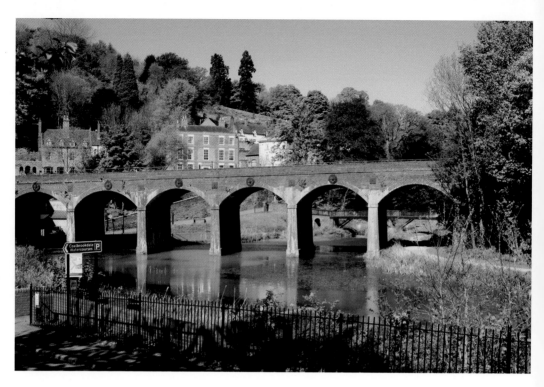

Upper Furnace Pool

Another photograph which shows how dramatically the arrival of the railway changed the landscape. In the 1860s photograph, Greenbank Farm, which still survives, is prominent on the right. The wooden footbridge replaced an earlier, very attractive cast iron bridge made at the Coalbrookdale Works.

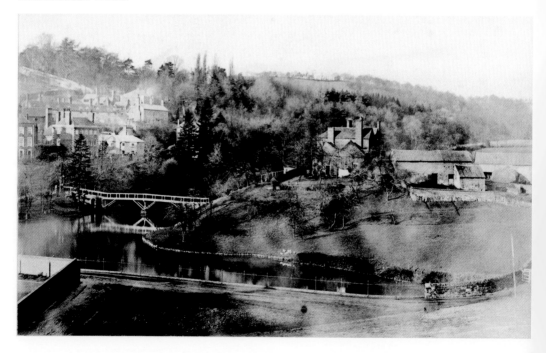

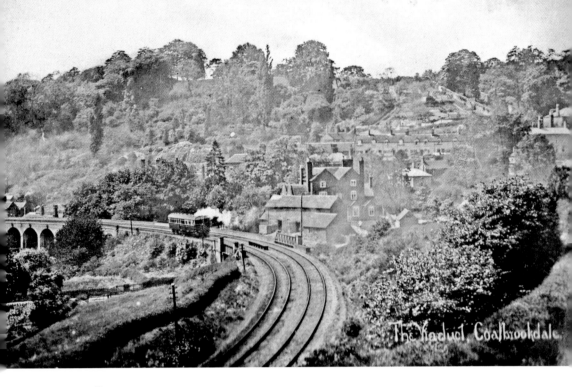

Steam Railmotor

One of the short-lived steam railmotors, which operated on the line in 1906, descends towards Coalbrookdale. The long, curving viaduct, which was on a steep gradient and also had to cross water, made this a very expensive stretch of line to build.

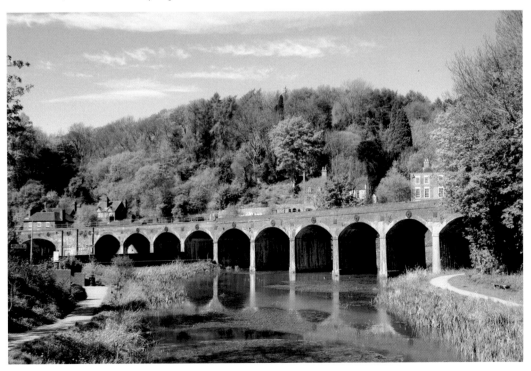

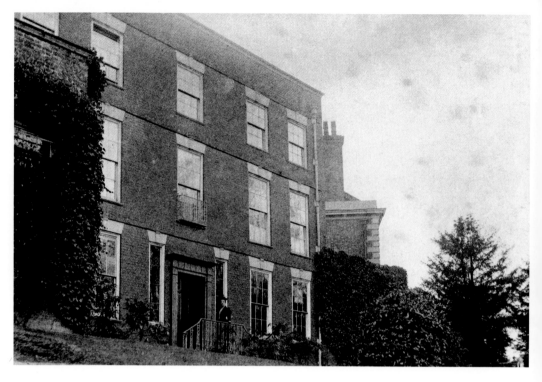

Dale House

This is the imposing house that the first Abraham Darby had built for himself, looking down on his works. He never lived in it, however, as he died shortly before its completion in 1717. It was in a sorry state of neglect by the late 1970s, but it has since been restored and is open to visitors during the summer months.

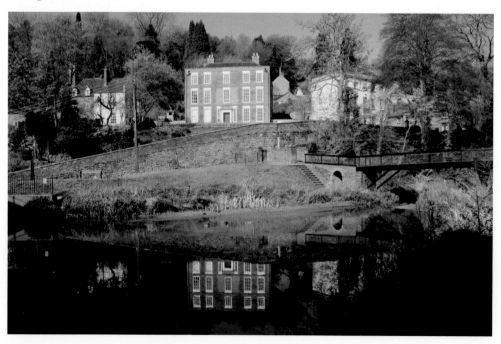

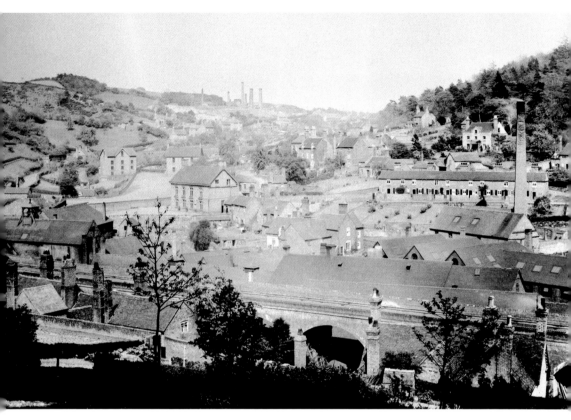

Upper Works

View looking north-east across the
railway viaduct towards the brickworks
chimneys at the top of Cherry Tree
Hill. The surviving 1780s row of
workers' housing known as Carpenter's
Row is prominent centre right,
whilst centre left is the former girls'
and infants' school, now in use as a
community centre.

What are you Looking at?

Today's museum visitors come and go in their bus loads during the summer months. In the earlier view, the Coalbrookdale Company workforce appears amused at the arrival of something as new fangled as a plate camera. Their aged appearance reminds us that there was no automatic retirement age, or state pension, for them to look forward to in those days.

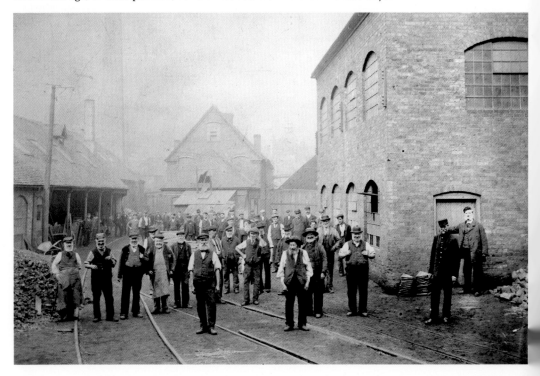

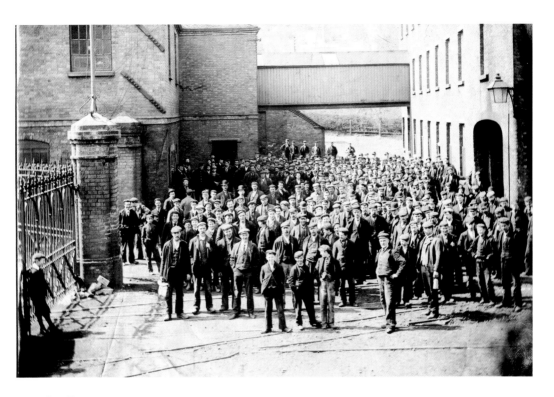

Pay Day

A directory of 1900 states that 'upwards of 1,000 people are employed in these works', though this figure would have included those at Lightmoor Brickworks and elsewhere. At one time the weekly wages were brought up from the bank in Ironbridge by two employees in a wheelbarrow! The buildings are now in museum use and a locomotive, since moved to Blists Hill, is seen on its way out of the paint shop in April 2001.

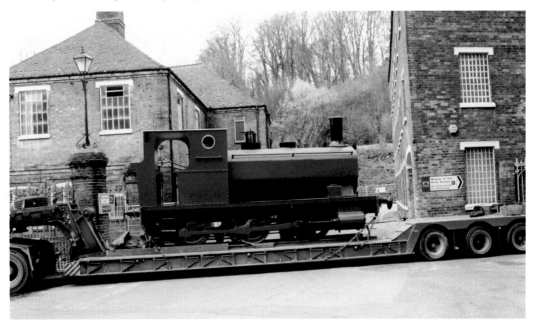

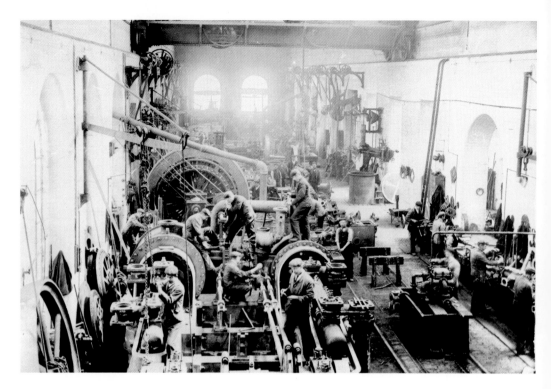

Erecting Shop

Small steam engines and pumps being manufactured in the Erecting Shop at the Coalbrookdale Works in the late nineteenth century. The outside of the building proclaims the significance of the site to passing motorists, whilst the banner commemorates the 300th anniversary of Abraham Darby's great achievement, celebrated in 2009.

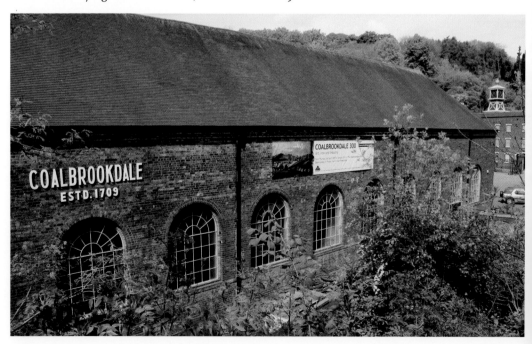

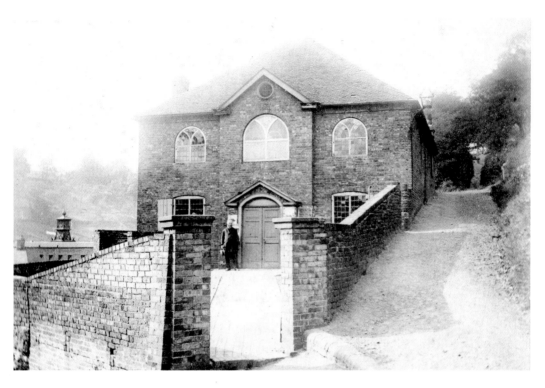

Fletcher Memorial Chapel

Whilst the management and upper echelons may have been Quakers, many of the Coalbrookdale workforce and inhabitants were Methodists. A chapel commemorating John Fletcher, vicar of Madeley, was erected in 1785, the year of his death. One hundred years later it was replaced by a much larger one, seating a congregation of 200. As in many other places, the chapel has closed and is now used for light industry.

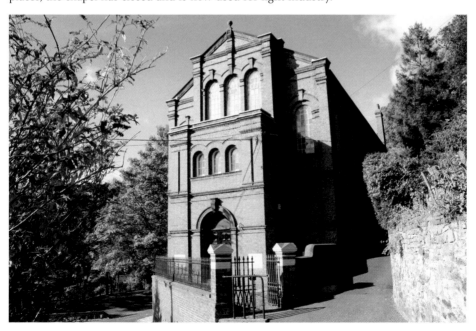

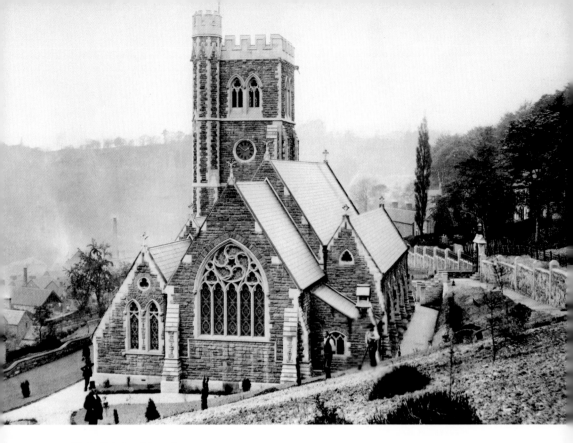

Holy Trinity Church

A new Parish of Coalbrookdale was created in the early 1850s, and a church erected, paid for by Abraham Darby IV. He had fallen out with the family, and spent much of his working life in South Wales, but came back to Coalbrookdale to be buried. His impressive white marble tomb can be seen just below the large window at the end of the church.

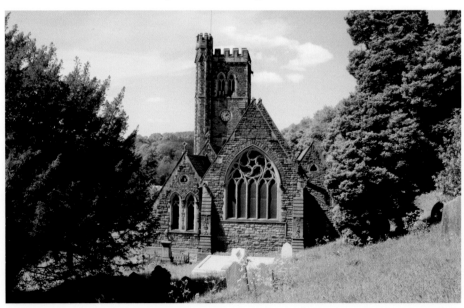

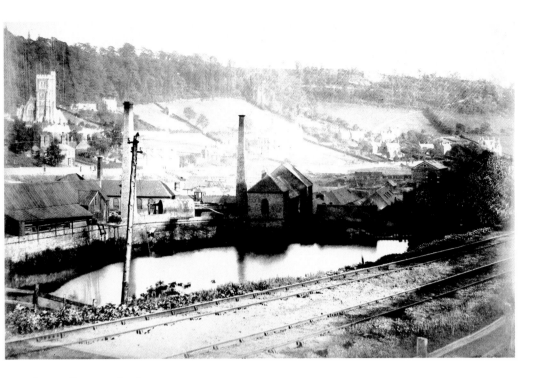

Lower Furnace Pool

View looking south eastwards across the Lower Furnace Pool, with Abraham Darby's New Furnace of 1715 prominent in the centre. This pool had been completely filled in as early as 1902. The 1993 view looking in the opposite direction was taken from the top of the church tower, before the blue smoke of the cupola — a familiar sight since the 1700s — was banished to meet clean air regulations.

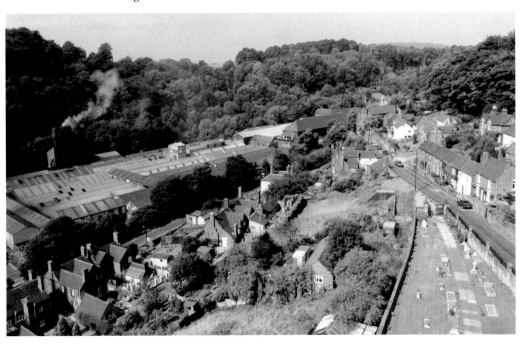

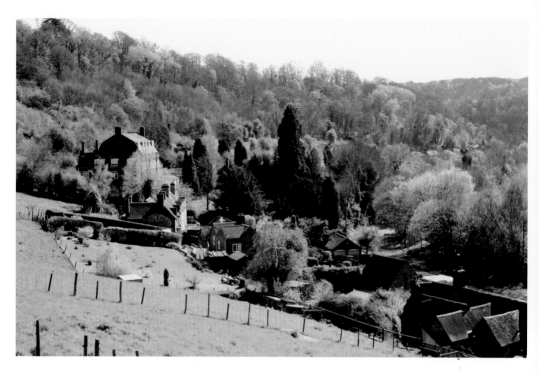

Upper Forge Pool

Spring bursts forth as the pussy willows and other blossoms appear on the trees of Coalbrookdale. The Upper Forge Pool has since disappeared under buildings and a car park, though its impressive sluices can still be seen further down the valley. This photograph can be dated to 1859, as the Literary and Scientific Institution, seen under construction centre left, was opened in that year.

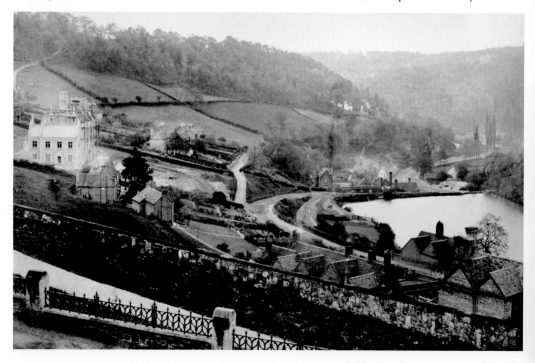

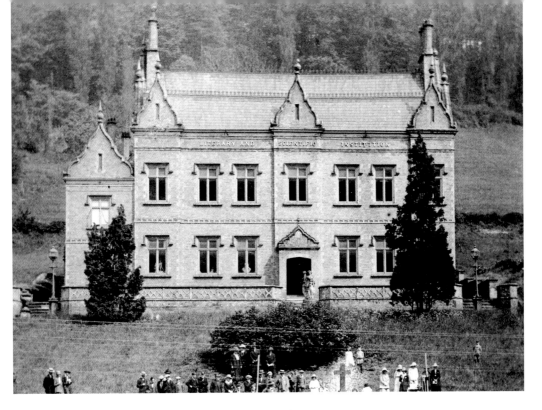

Coalbrookdale Literary and Scientific Institution

This shows the building as erected, with its name in raised lettering emblazoned across the top, and a pitched roof. Hundreds of local craftsmen attended the School of Art based here, and the building also housed a substantial library and staged lectures, concerts and exhibitions for the public. Later it was rebuilt with a mansard roof, and the lettering was removed. Since 1980 it has housed the Coalbrookdale Youth Hostel.

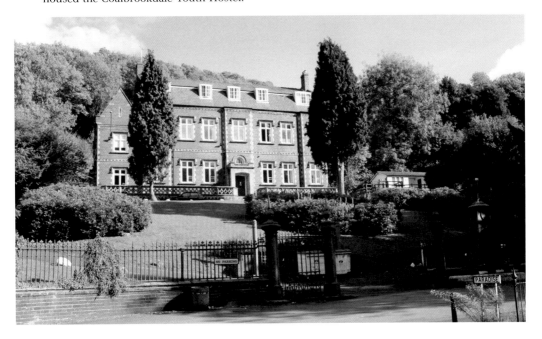

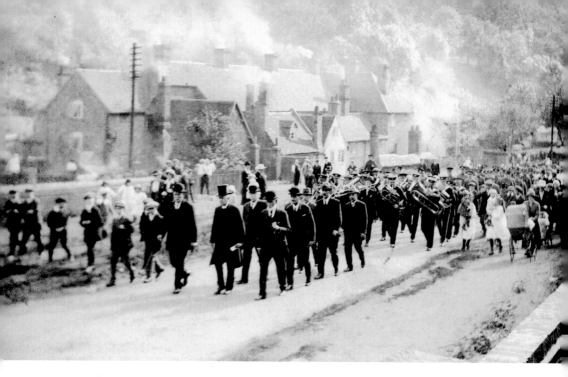

Upper Forge

A parade passes the Upper Forge on its way to the unveiling of the Coalbrookdale War Memorial in 1921. An important archaeological excavation beneath the cottages seen in the background a few years ago revealed the substantial remains of two steel furnaces from the seventeenth century, thus demonstrating that there was much significant metalworking going on in this valley long before the first Abraham Darby arrived in 1708.

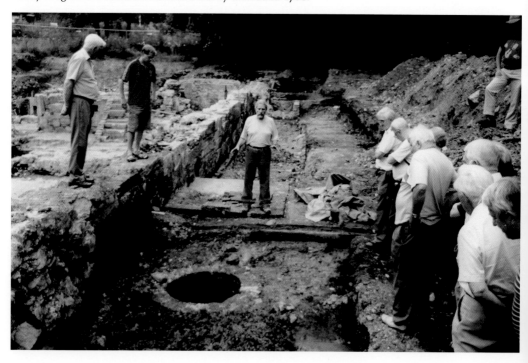

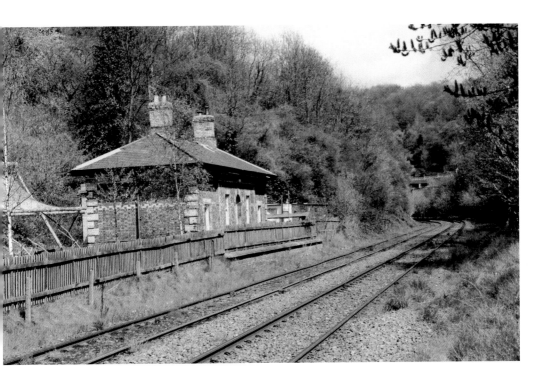

Coalbrookdale Station

The site of Coalbrookdale Station, including this surviving building on the up platform, is now occupied by the headquarters of the Severn Gorge Countryside Trust, who care for much of the surviving woodland in the area. The earlier view, looking south eastwards, shows not only an early standard gauge train in the station but also, beyond it, a much earlier plateway running down the road towards the river. The large maltings seen centre right have since disappeared.

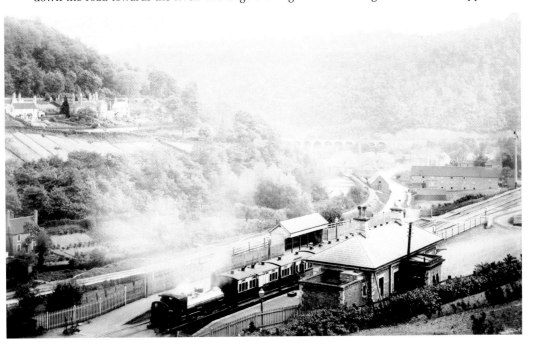

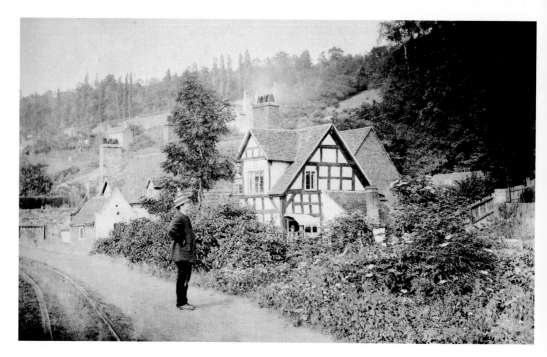

Rose Cottage

This cluster of cottages at 4-7 Dale Road are known collectively as Rose Cottage and date from 1642. They were amongst the first properties to be restored by the Ironbridge Gorge Museum Trust in the 1970s but unfortunately suffered serious flood damage — since repaired — during the notoriously bad summer of 2007. The plateway seen in the distance in the previous photograph can be seen bottom left.

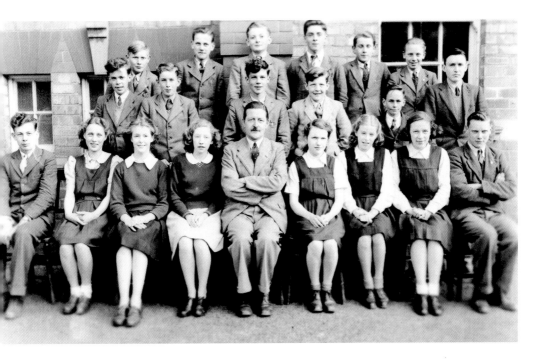

Coalbrookdale County High School

When teacher Jack Cook and his class posed for this photograph in the late 1940s, the impressive building at the bottom of the Dale, opened in 1911, was still a secondary school. Since the 1970s, it has been converted into a highly successful junior school, with all local secondary education moving up the hill to Madeley.

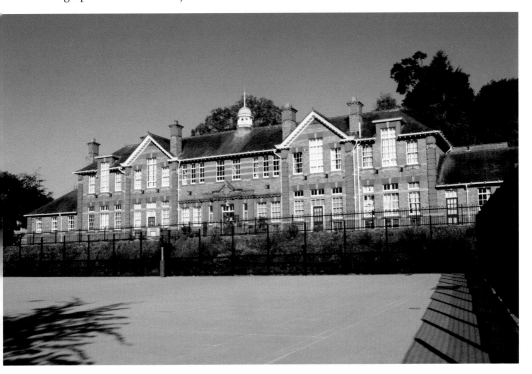

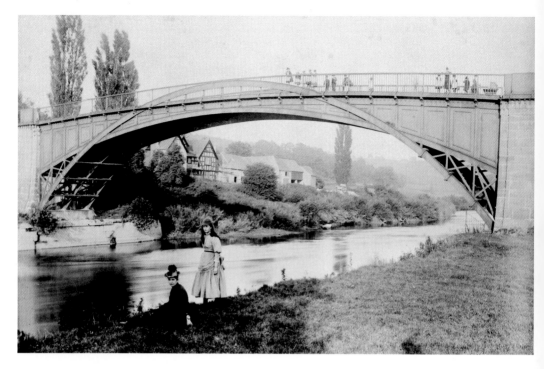

Buildwas Bridge

Buildwas is at the western entrance to the Ironbridge Gorge. It is here that Thomas Telford built this fine Coalbrookdale cast iron bridge in 1796, the previous one having been badly damaged in the great flood of 1795. The 1992 bridge is functional, yet somewhat featureless by comparison. A few traces of Telford's original can be seen at the foot of the north parapet to the left, and the plate bearing the date is preserved on a nearby plinth.

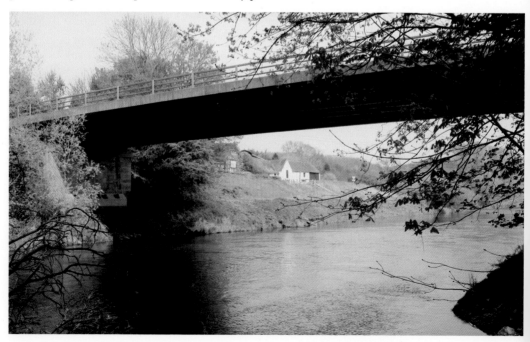

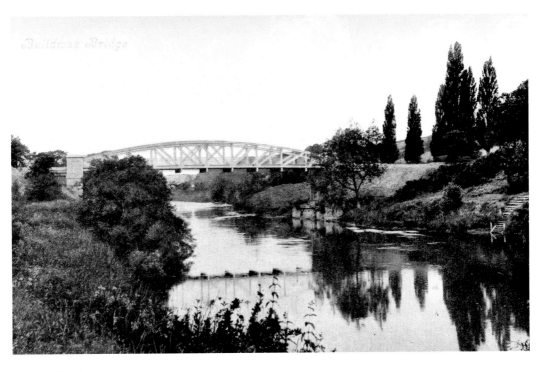

Telford Replacement

Despite an engineer's report in 1888 stating that 'no special action' was necessary to strengthen it, Telford's bridge was affected by ground movement, and had to be replaced by a new steel bridge in 1905. A temporary Bailey bridge was installed when this in turn was dismantled to make way for its concrete successor. Again, ground movement was the reason.

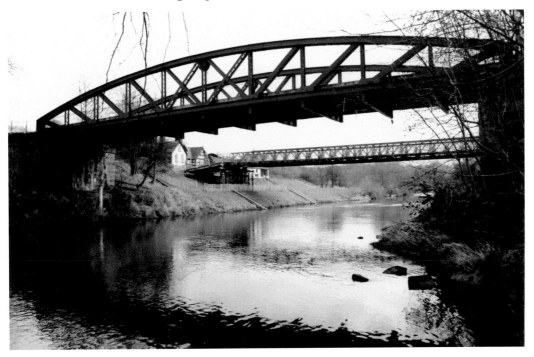

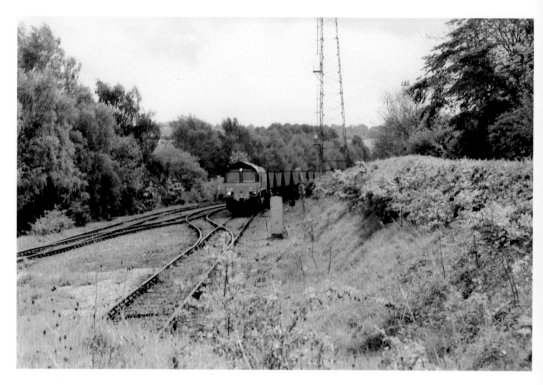

Buildwas Junction

Nowadays it has been obliterated, apart from this nearby headshunt for coal trains, but once Buildwas Junction was an important station, where it was possible to catch trains to Shrewsbury, Worcester, Wellington or Craven Arms. A steam train with Bert Bostock on the footplate heads towards Shrewsbury shortly before the closure of the line to passengers.

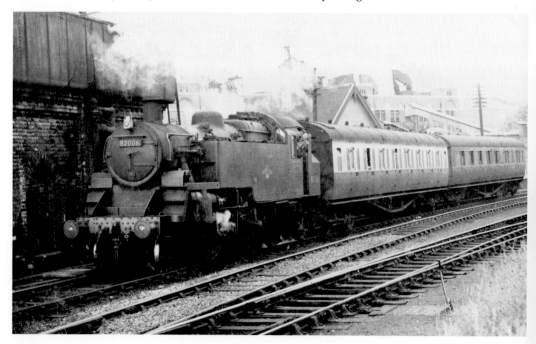

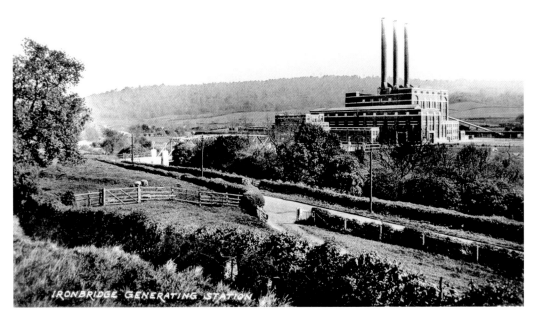

IRONBRIDGE GENERATING STATION

The Age of Electricity

In 1932, the West Midlands Joint Electricity Authority opened the first Ironbridge Power Station (actually just over the parish boundary in Buildwas), having chosen the location because of the availability of local coal and water for cooling purposes. This shows it as built, with three steel chimneys, though three more were added later on. It was demolished in 1982-3 following closure; however, the truss girder access bridge remains *in situ.*

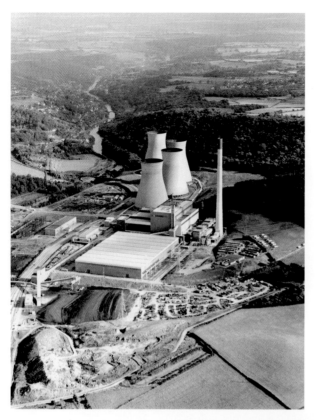

Ironbridge 'B'

Work began on a massive replacement station, to be known as Ironbridge 'B', in 1963, though it took almost a decade to complete. Due to its sensitive location, the cooling towers were given a special pink colouring, and arranged in a sweeping crescent. Steam from them can be seen from miles around on a frosty day. Originally due for closure by 2000, the station's life will now extend well into the second decade of the twenty-first century.

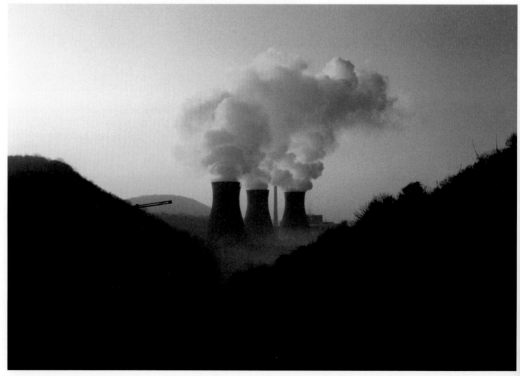

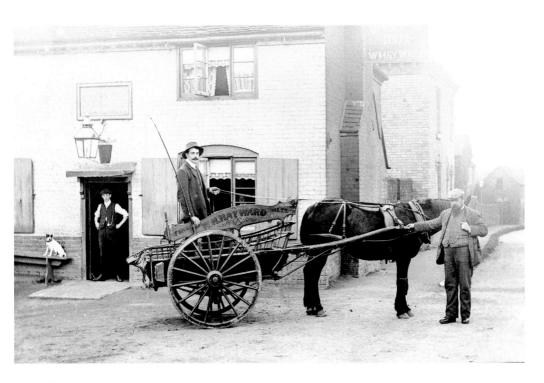

Meadow Inn

Staff, including the dog, pose for a photograph outside the Meadow Inn, between Ironbridge and Buildwas. The lettering on the dray and the inn sign informs us that the proprietor was one W. H. Hayward. The building has since been enlarged considerably and is dwarfed by the cooling towers across the river.

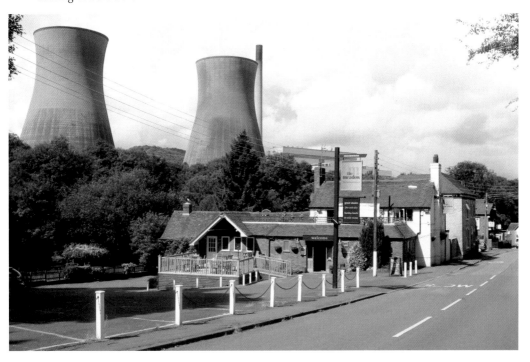

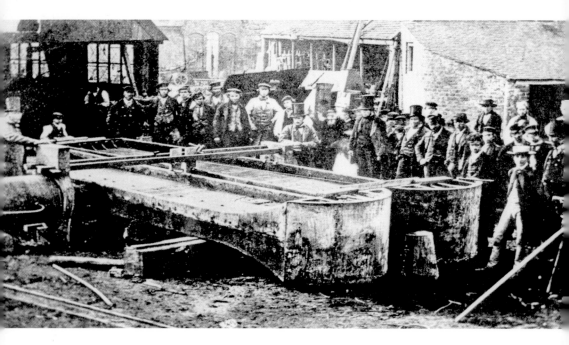

Testing the Albert Edward Bridge

Despite its poor quality, this is an important photograph, showing the testing of a component for the Albert Edward Bridge, at the Coalbrookdale Works, prior to its erection in 1863. Could one of the top-hatted gentlemen to the left be the engineer, John Fowler? A view looking upwards from underneath the bridge shows where this piece, with its curved end, fits in.

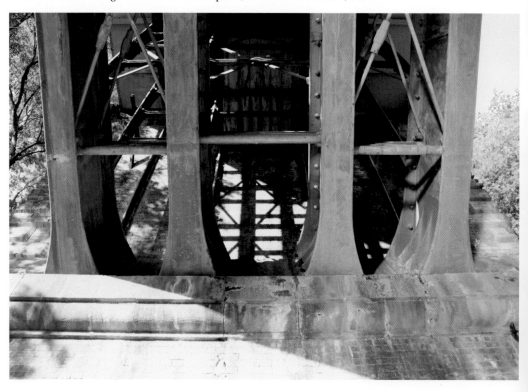

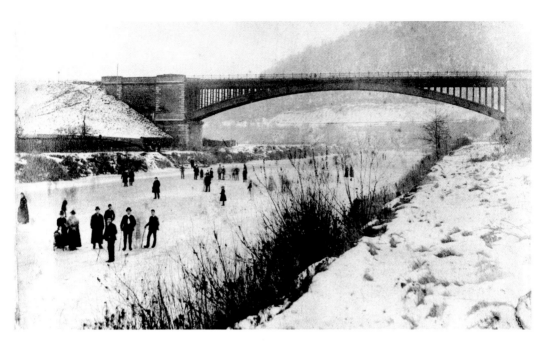

Skating on the Severn

This photograph, which probably dates from the harsh winter of 1890-1, shows people skating on the River Severn beneath the Albert Edward Bridge, looking downstream. The bridge survives, though without the original decorative handrail, to carry coal trains across to the power station. The Victoria Bridge on the preserved Severn Valley Railway just south of Arley is practically identical but is single track, whilst this one is double track.

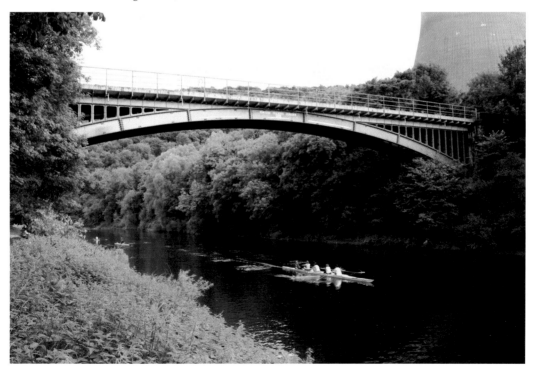

Meadow Ferry

The slopes on the south bank of the river are once again covered in lush vegetation, the scar created by the building of the Severn Valley line having long since grown over. Prior to the coming of the power stations there was a cluster of houses on the south bank whose residents made use of this ferry, thereby avoiding a long walk round via Buildwas or Ironbridge.

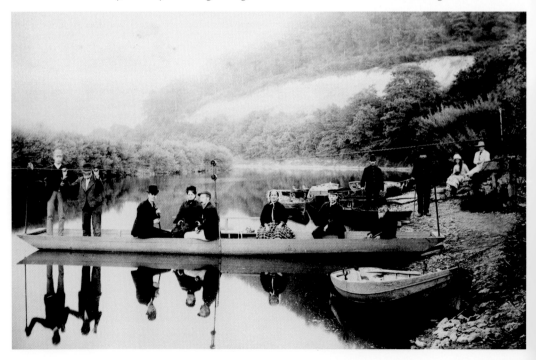

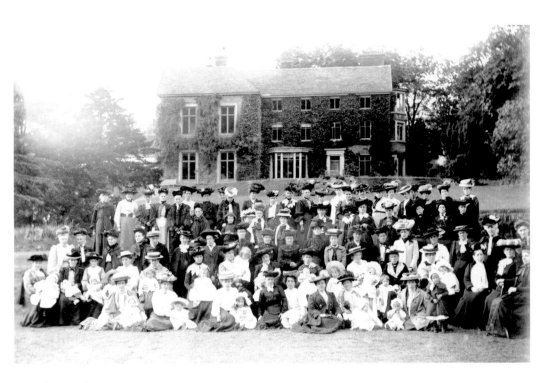

Severn House

There's something in the region of seventy hats visible in this marvellous photograph taken in front of Severn House. Are there any two the same? Once the home of members of the Darby family, then the Maw family of tile makers, and subsequently pioneer electrical engineer Thomas Parker, Severn House is now the Valley Hotel, and the spot where the picture was taken part of Dale End Park.

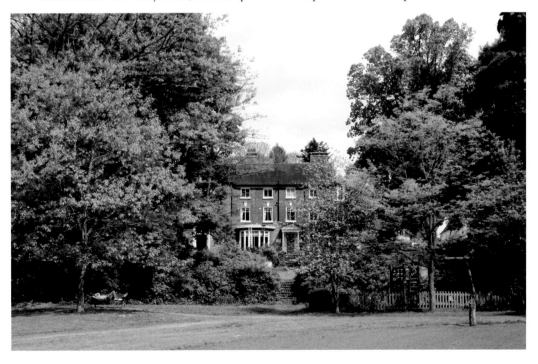

39

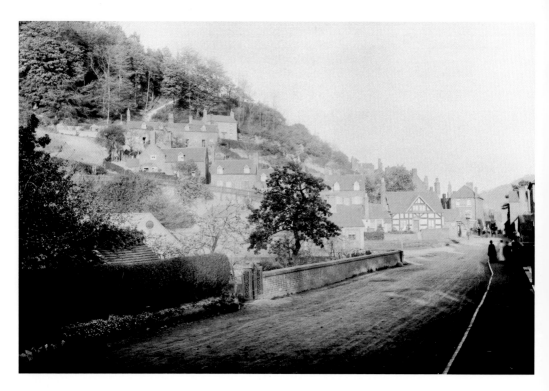

Dale End

Where Coalbrookdale merges into Ironbridge, Dale End is one of several locations in the Gorge which used to have many more humble workers' dwellings than it does now. Those extending up the slope to the left of the surviving black and white Yew Tree Cottage were in a row which went by the delightful name of Pan Shop Bank.

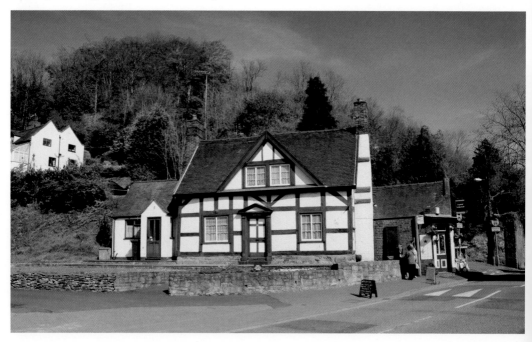

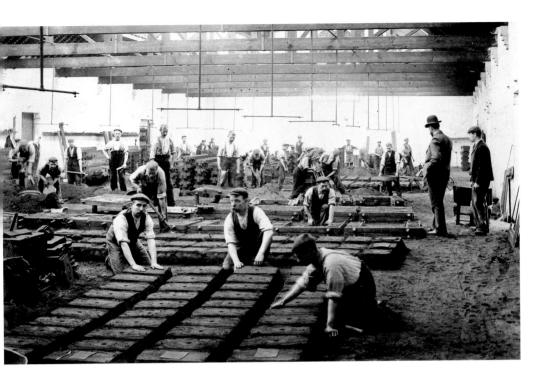

Teddy Bears' Picnic

The large red brick Severn Foundry at Dale End, dating from 1901, represented the Coalbrookdale Company's last major expansion. Its success was short-lived, and for much of its life the building has been used for the manufacture of world famous Merrythought teddy bears, which are sold in an adjacent shop. Shop manageress Barbara Stewart, who has sold thousands over the years, is pictured shortly before her retirement in 2009.

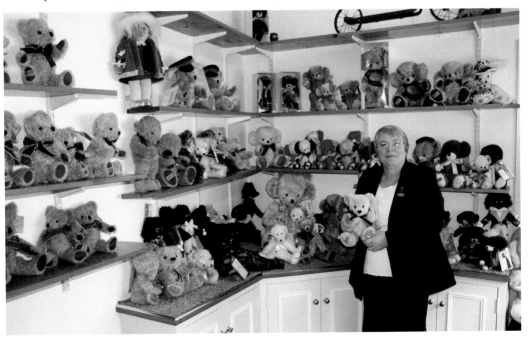

Nailer's Row

Now serving as a car park, this area was one occupied by a row of houses called Nailer's Row, which were particularly prone to flooding, residents having to be rescued from upstairs windows by boat. The reference points are the surviving Rodney Inn, now converted into flats, and the squatter-type residences alongside, which are still there, as is the more modern house to the east with different coloured tiles on the roof.

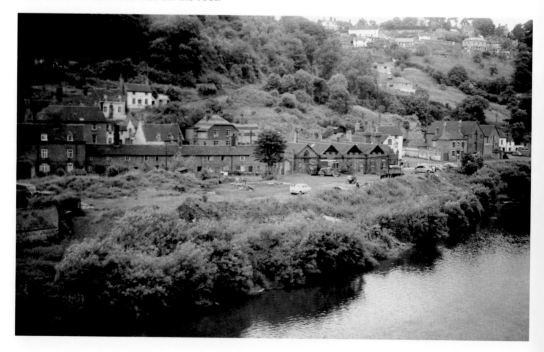

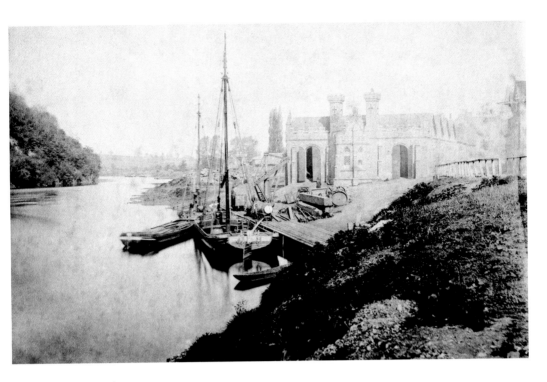

Severn Warehouse

An early photograph of the warehouse constructed at Loadcroft Wharf by the Coalbrookdale Company in 1834. Goods were brought down the valley by plateway before being transhipped onto river vessels for the journey down to Worcester, Gloucester and Bristol. In use until the 1880s, it was restored for museum use in 1978, after many years as a mineral water bottling factory, and then a garage. It now houses the Museum of the Gorge.

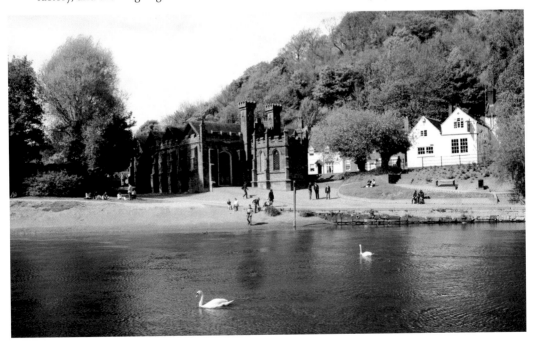

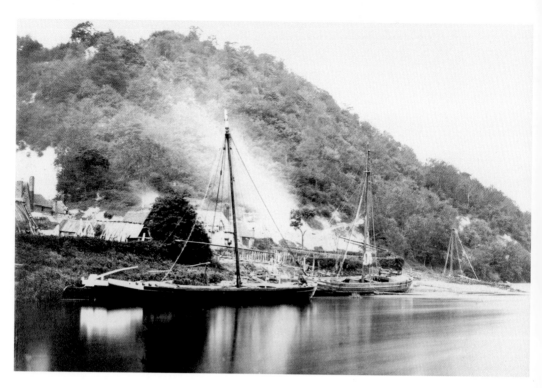

Bower Yard

Sailing vessels, with iron hulls as well as wooden ones, were built and repaired in the Ironbridge Gorge well into the nineteenth century, some of them here at the Bower Yard on the south side of the river. The only sizeable vessels to be seen on the river in recent years have been two short-lived trip boats. In truth, there is little to be seen from a boat that cannot be seen equally well from the bank.

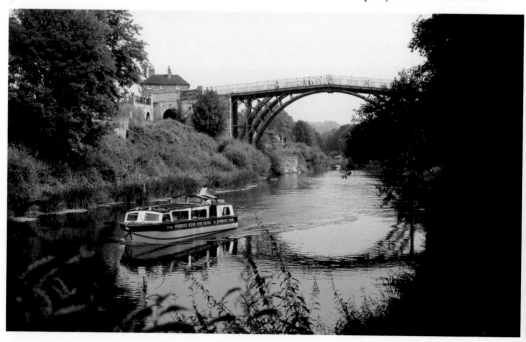

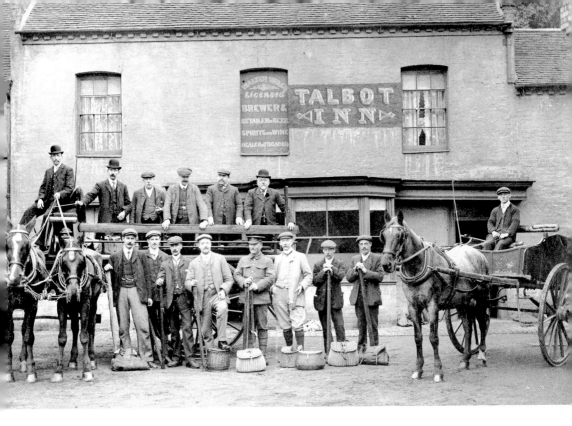

Talbot Inn

A fishing party outside the Talbot Inn, on the Wharfage, Ironbridge. Set well back from the road, the space in between was once occupied by numerous outbuildings. In recent times, its name has been changed to the Malthouse, and it is now a well-known restaurant, very popular with both locals and visitors.

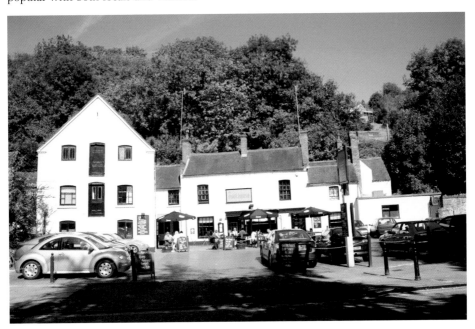

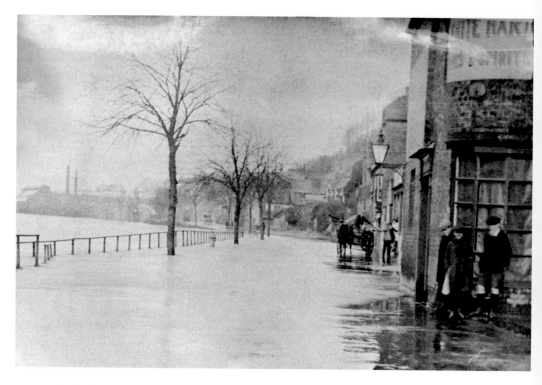

Never Mind the Weather

Until the introduction of portable barriers a few years ago, floods of varying severity were a frequent occurrence along the Wharfage in Ironbridge. In the early twentieth century view, the milkman gets through in his pony and trap, keeping well away from the strong currents nearer the barriers. In February 1991, a determined party of schoolchildren staying at the youth hostel are not letting an overnight fall of snow deprive them of their visit to the Iron Bridge.

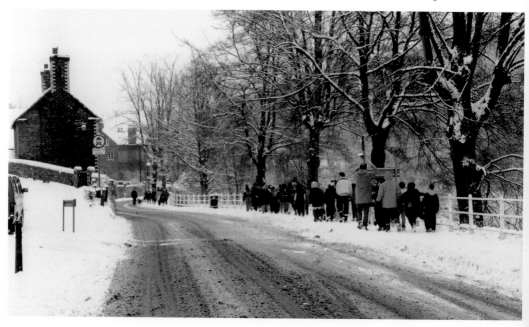

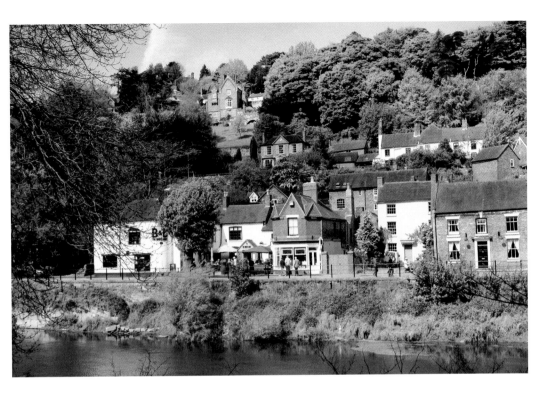

White Hart

Seen from across the river, the White Hart, with its secluded little courtyard, still offers overnight accommodation and remains a popular eating and drinking establishment. The tree seen in the earlier view has long since disappeared. The staff have all turned out to have their photograph taken, though the old gaffer with a stick looks more like a customer they couldn't get rid of!

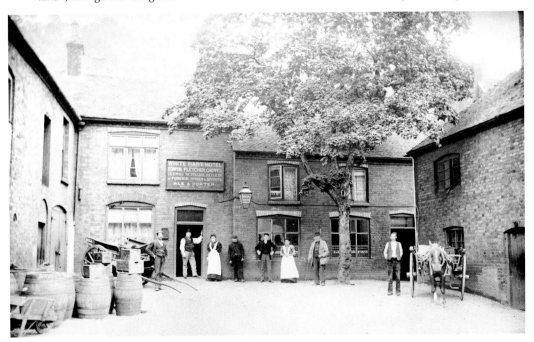

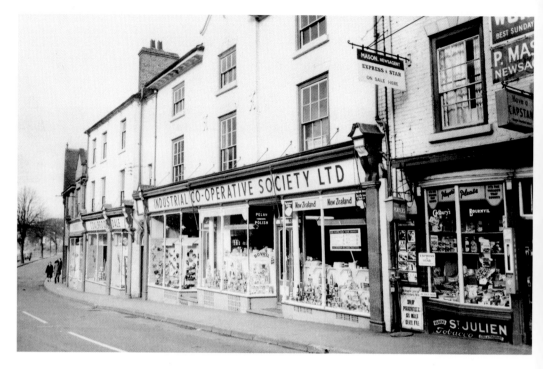

The Co-op

Even comparatively small towns like Ironbridge could once boast their own department store. This is the premises of the Ironbridge and Coalbrookdale Industrial Co-operative Society Ltd., who had other shops in the locality in addition to this one. For a number of years, the offices of the Ironbridge Gorge Museum Trust were located here, though they have now reverted to retail and residential use, providing shops and a café for visitors.

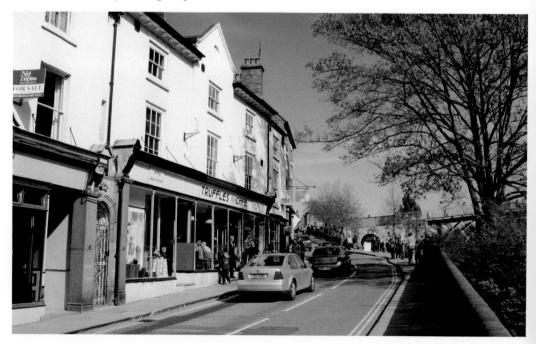

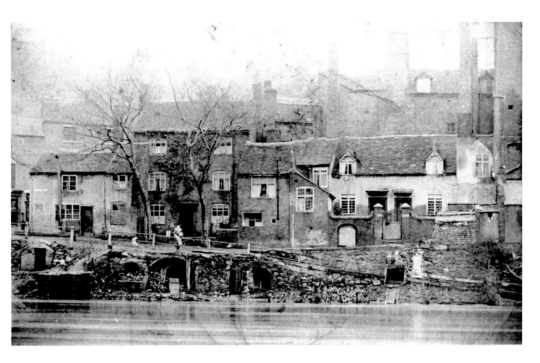

Severnside

The sloping roofline in the background provides the clue as to where these houses once stood. They are typical of many sub-standard and insanitary houses which were swept away during the twentieth century. Quite a contrast to the brightly-painted shops awaiting their first customers on a fine spring morning.

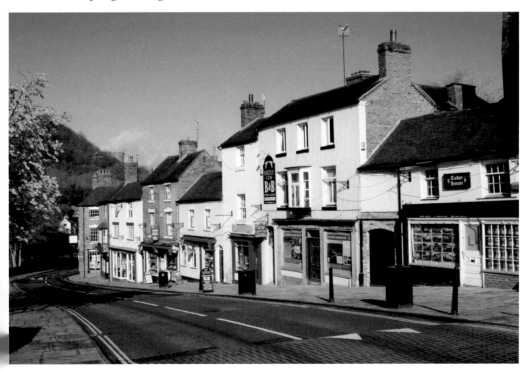

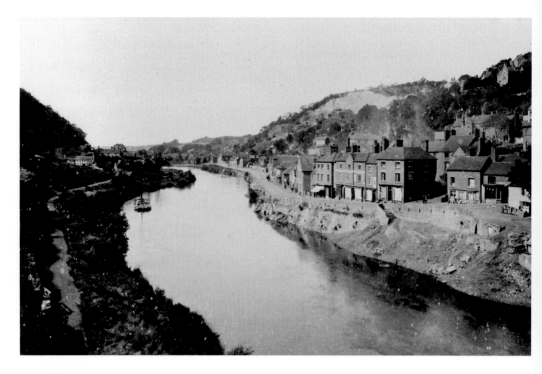

Wharfage and Lincoln Hill

This photograph shows a trow loaded with bricks moored just upstream of the Iron Bridge, so probably dates from the 1880s. The scars created on Lincoln Hill, where limestone was extracted in huge quantities both by quarrying and extensive underground mining, have still not completely healed.

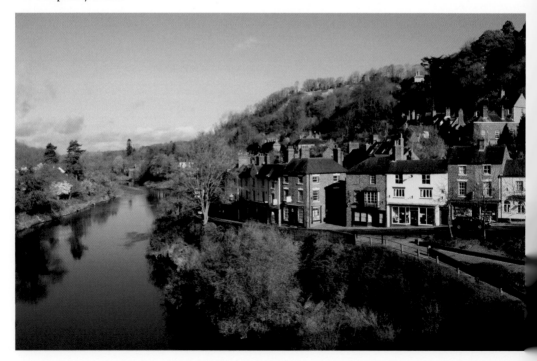

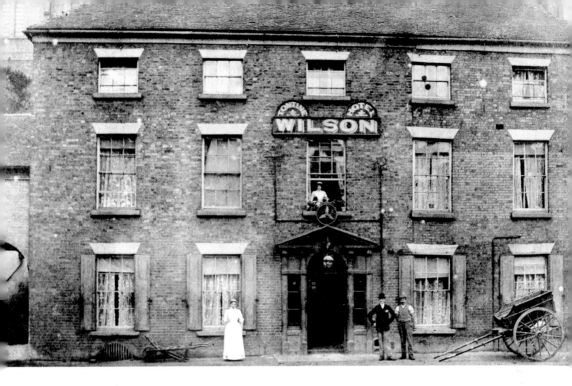

Tontine Hotel

The Tontine Hotel, at the north end of the Iron Bridge, was completed in 1784, three years after the bridge itself opened. It was extended eastwards by two bays in 1786-7. Thomas Barnes Wilson, proprietor when the earlier photograph was taken, also owned the Crown Hotel and pleasure gardens in Hodge Bower, which were a very popular destination for works outings from Wolverhampton and the Black Country during Victorian times.

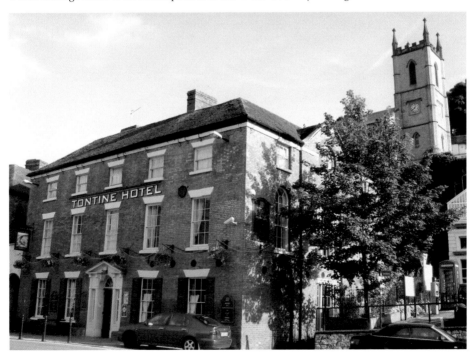

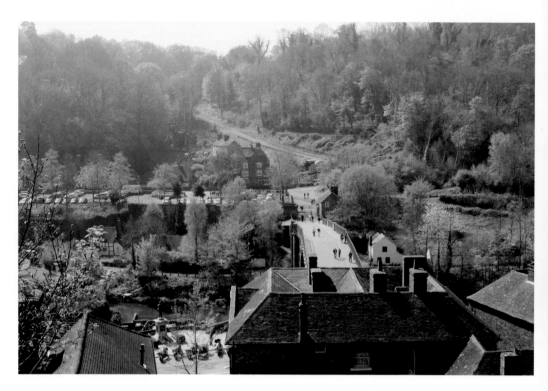

Iron Bridge from the North

The main difference between this contemporary view looking southwards up Benthall Bank and the earlier one is the complete disappearance of Ironbridge and Broseley Railway Station, with its extensive goods facilities and sidings. The area is now the car park for the Iron Bridge. Halfway up the bank, above the large goods shed, can be seen Benthall Mill, with its massive waterwheel which went for scrap before the Second World War; however, the ruins of the buildings remain.

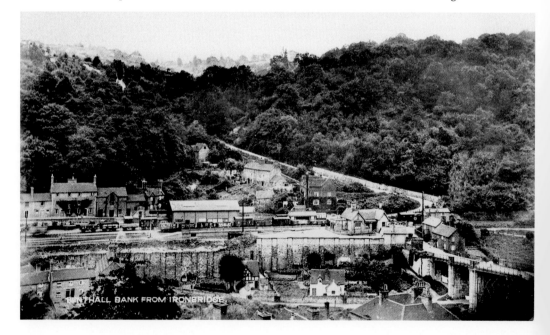

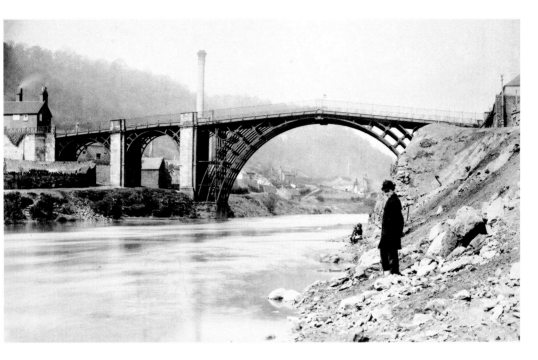

Iron Bridge from Downstream

Prominent in this view is the White Brickworks, just beyond the bridge. The impressive chimney was reduced in height after being struck by lightning in the 1890s. This is probably a posed photograph, but goodness knows what the babe in arms in the distance is breathing in, as the river was little more than an open sewer at this time.

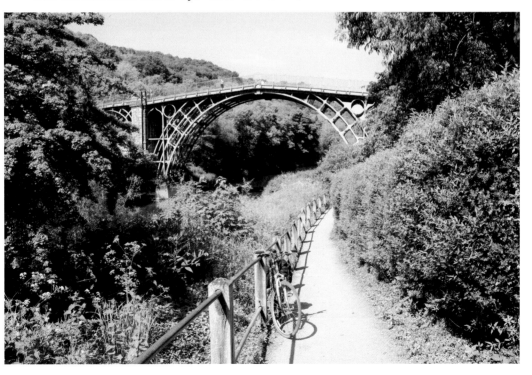

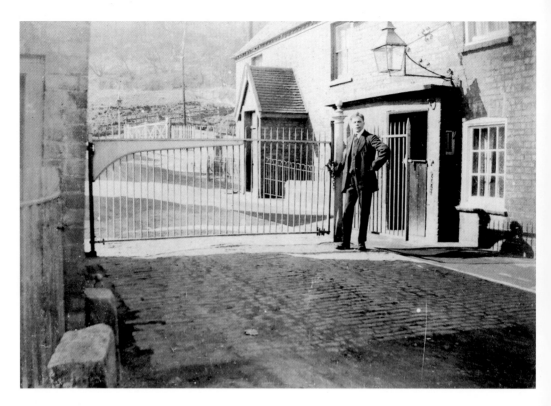

Please Pay Here!

The toll keeper awaits payment on the Iron Bridge. Until formally handed over to Shropshire County Council in 1950, it was always a toll bridge, and the notice on display emphasises that even members of the royal family are expected to pay. Her Majesty the Queen walks towards the tollhouse during her visit on 10 July 2003.

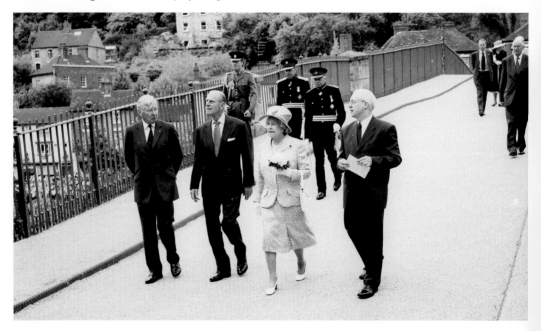

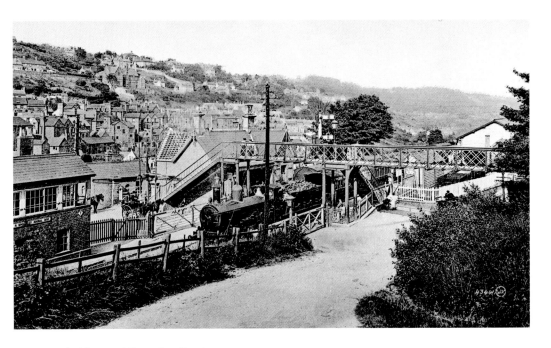

Ironbridge and Broseley Station

View looking north eastwards across the station, with a Shrewsbury bound train in the platform. Delays for vehicular traffic could be lengthy here, if shunting was going on, though foot passengers could cross by means of the bridge. The line followed the Severn Valley most of the way from Hartlebury to Shrewsbury, and a section further south, between Bridgnorth, Bewdley and Kidderminster, is one of the most scenic preserved lines in the country.

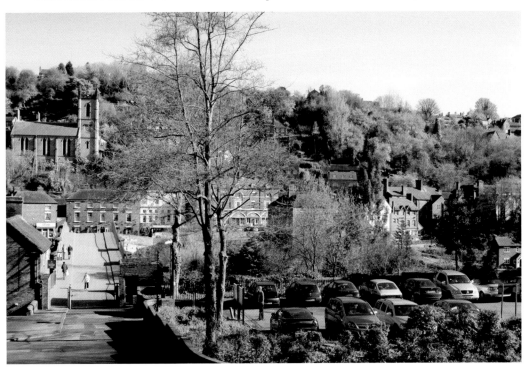

Maw & Company

There's precious little to be seen today of the tile works established by the brothers George and Arthur Maw in 1852, just up the hill south of the Iron Bridge, on the site of the former Benthall Ironworks. There are the remains of a wall on the east side of the road, but nothing much else above ground. The factory re-located to Jackfield in 1883.

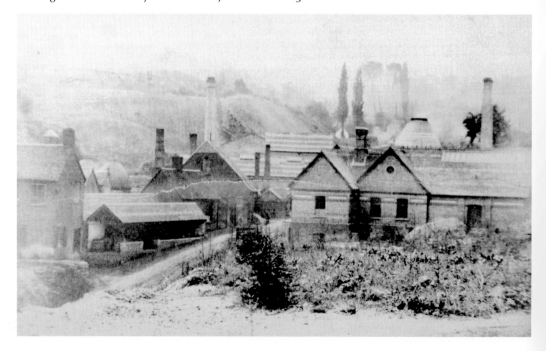

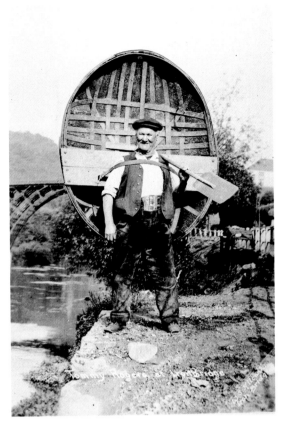

Ironbridge Coracles

Several generations of the Rogers family built and used coracles in the shadow of the Iron Bridge. This is the celebrated coracle maker and poacher, Tommy Rogers, whose exploits were legendary. The last survivor was his grandson Eustace Rogers, who died in 2003. He is pictured in the garden of his cottage enjoying the evening sunshine, with the beginnings of a new coracle visible on his lawn in the background.

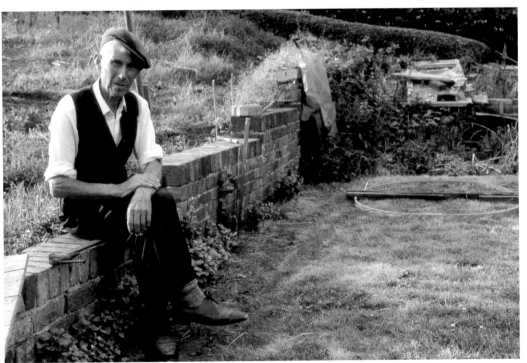

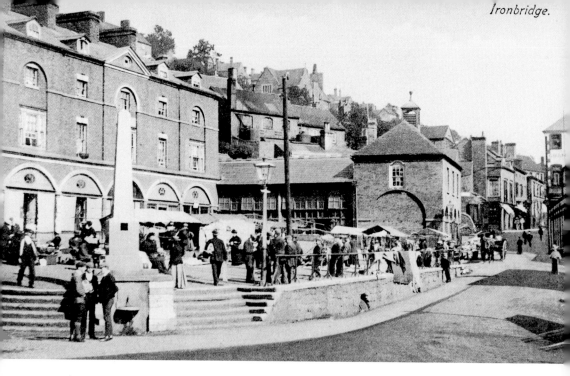

Market Day

Ironbridge once had a busy market every Friday, to which people would travel from many miles around. It finally petered out in the 1980s, and nowadays similar crowds are only seen on special occasions, such as the Ironbridge Gorge World Heritage Site Festival. This view shows local schoolchildren dancing round the maypole at the 2006 Festival.

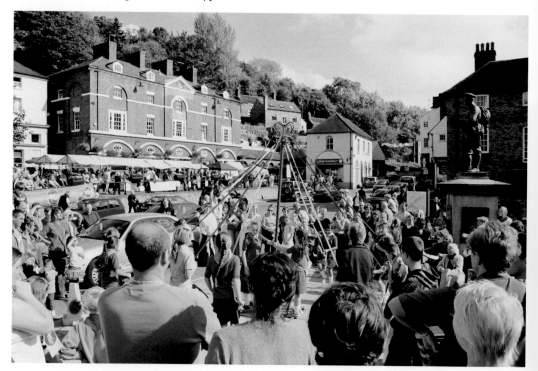

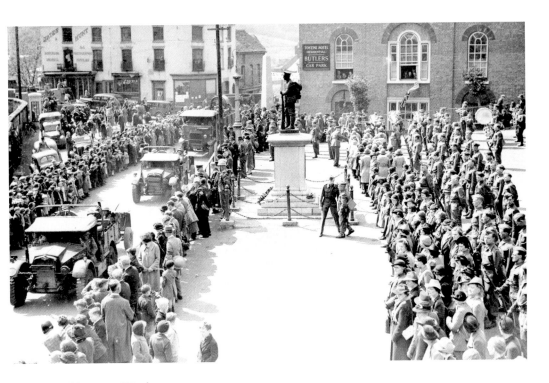

War Weapons Week

A military parade in Ironbridge to raise money for war weapons during the Second World War. The block of buildings centre left, just north of the Iron Bridge, were demolished after the war to make way for a replacement bridge which, fortunately, never happened. The war memorial has since migrated to the other side of the road, whilst the obelisk has been moved to a small garden in Waterloo Street.

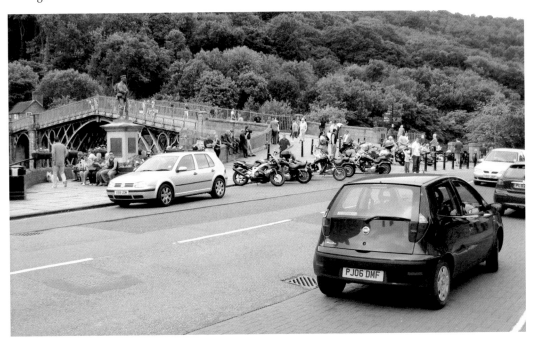

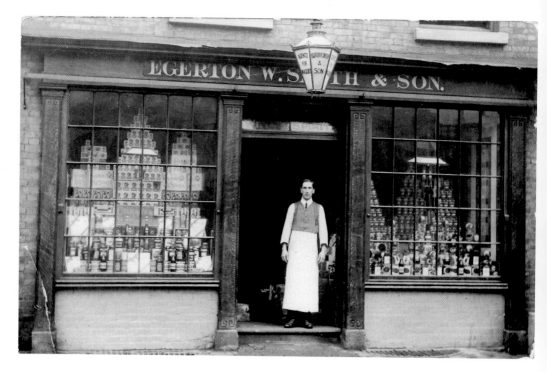

34 High Street

Egerton William Smith & Son is described in a 1900 directory as 'grocer, provision merchant and agents for W. & A. Gilbey Limited, wine & spirit merchants'. Items in the window to the left include Colman's starch and apricot jam! The building was restored in the 1970s by the Landmark Trust, who have a holiday let on the top floor with splendid views of the Iron Bridge. The ground floor houses the Ironbridge Gorge Museum gift shop.

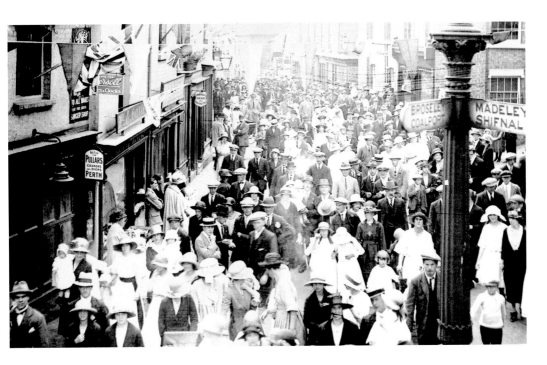

Ironbridge High Street

Crowds clearing after watching a parade by the Ironbridge Territorials in 1923. Some of the shops on the left have now gone, and there is a mini-roundabout here, replacing the T-junction whose signpost is prominent on the right. The early 1980s view was taken from the upstairs window of Beddoes' ironmonger's shop, on a dank winter's day, with few visitors in evidence.

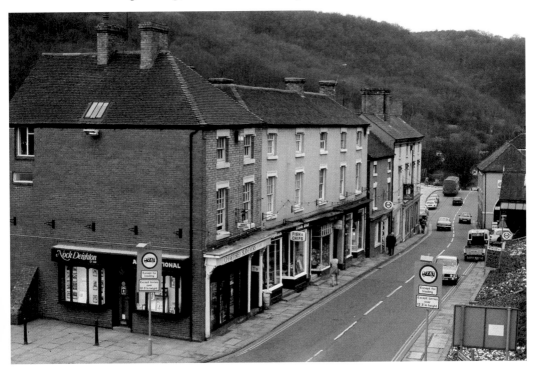

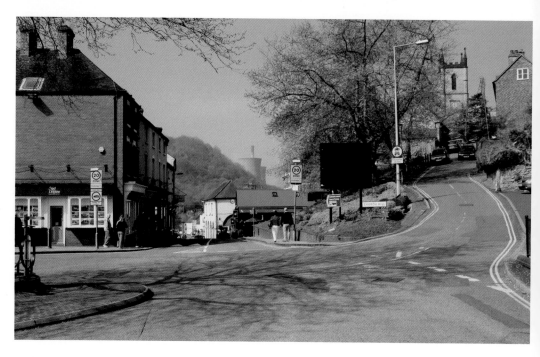

Church Hill, Ironbridge

A fine view on a spring morning from slightly further to the east. A century earlier, Simpson's were advertising 'Pianos & organs for sale or hire' and attracting window shoppers. The Municipal Buildings at the junction of the two roads have gone, to be replaced by a flower bed. The steep road up past St Luke's church (built 1836) was the northern approach to the Iron Bridge until Madeley Bank was constructed around 1810.

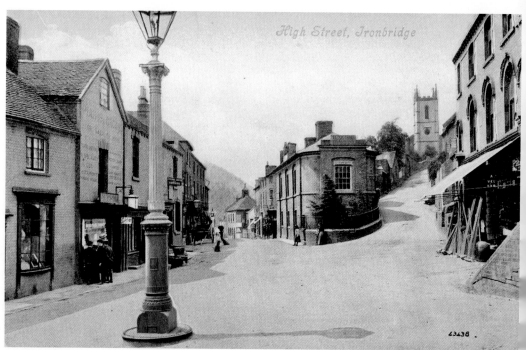

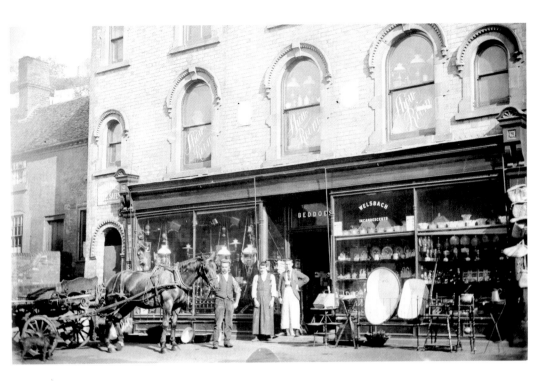

Beddoes' Shop

Frank Green Beddoes established himself as an ironmonger in Ironbridge in 1871. He had this purpose-built shop, with well-lit showrooms on the first floor and warehouses in Waterloo Street opposite, and he stocked everything from furniture and oil lamps to blasting powder, fuses and dynamite for local mines. Unable to compete with out-of-town DIY stores, the shop closed in the early 1980s and is now an estate agent's. Note the unusual profile of the end wall.

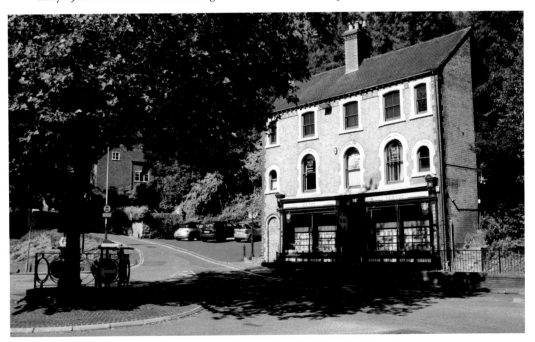

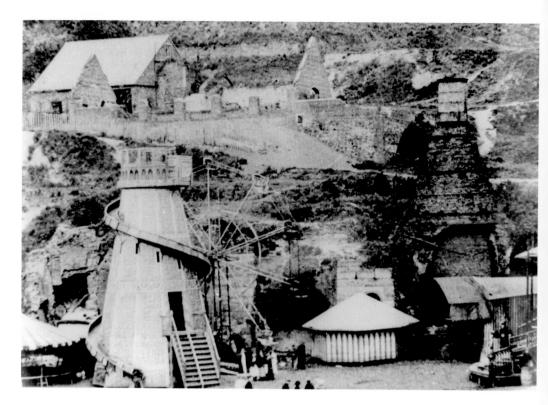

Bedlam Furnaces

The ruins of Bedlam Furnaces house a travelling funfair, complete with big wheel and helter-skelter in this undated photograph. Today, a fine view of them can be had from steps leading down to a fishing peg on the south side of the river. This is the location of 'Coalbrookdale by Night', painted by Philip de Loutherbourg in 1801, one of the best known of all paintings depicting the Industrial Revolution.

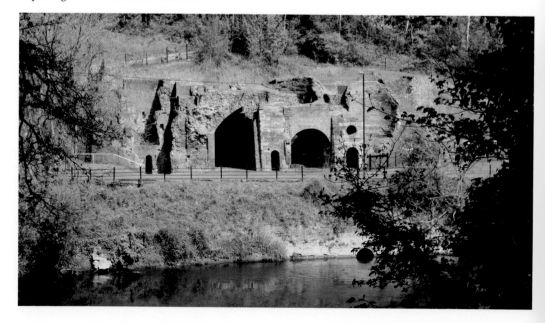

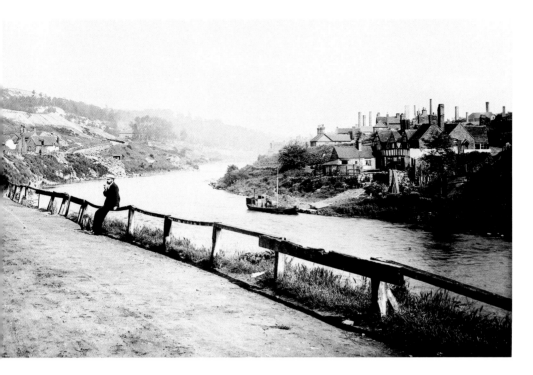

Jackfield Ferry

The lack of vegetation on the north bank of the river is very apparent in this late-nineteenth-century photograph. The half-timbered public house on the south bank, just above the ferry boat, is the Dog & Duck, long since disappeared. The man smoking a pipe is sitting not far from another pub frequented by watermen, the Bird in Hand, which still survives and can be seen in the trees to the right in the modern view.

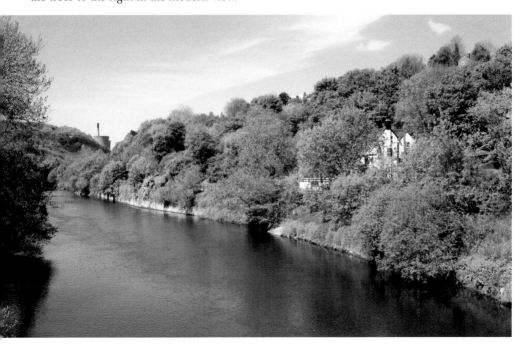

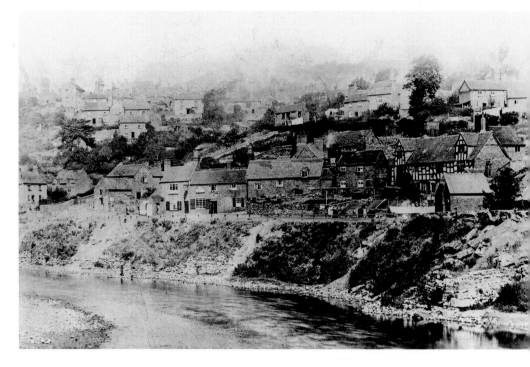

Robin Hood

The northern terminus of the ferry was at a public house called the Robin Hood, which survives as a very popular waterside pub to this day. Many humble houses have disappeared from this area, some of them on the slopes of Madeley Wood, up above, due to land slippage.

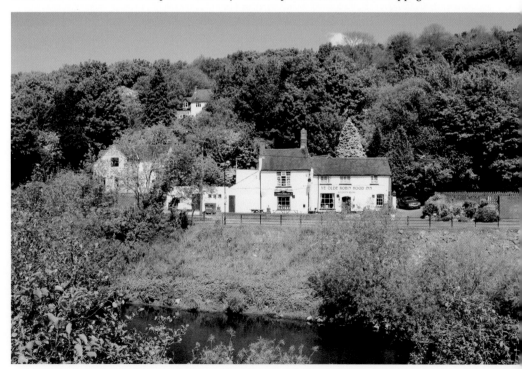

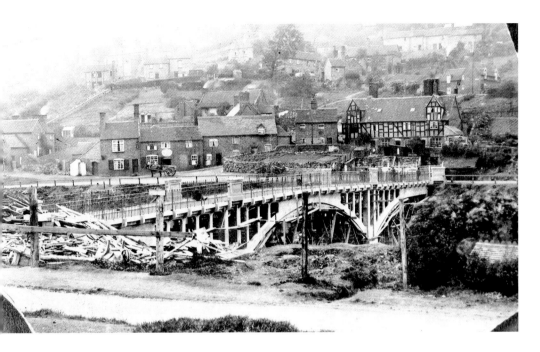

Free Bridge

A new ferro-concrete bridge across the Severn was built near the Robin Hood in 1909. Although officially called the Haynes Memorial Bridge, it became universally known as the Free Bridge, because there was no toll payable for crossing it. The wooden formwork is still in position in this photograph, taken before its opening. In the 1993 photograph, demolition is seen under way, with a temporary Bailey bridge *in situ* beyond.

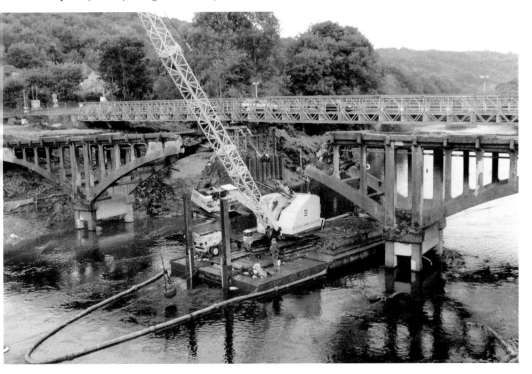

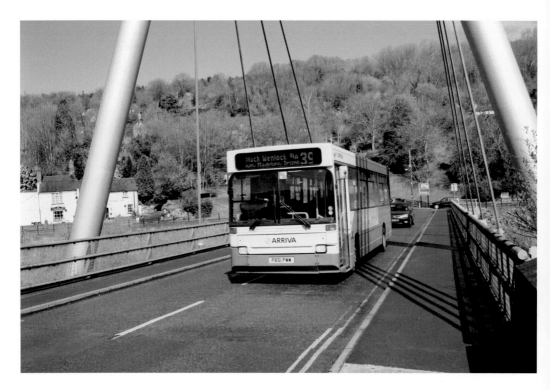

By Bus to Broseley

It's safe enough to cross by bus to Broseley on the modern replacement bridge, but things looked a lot less certain during this excessive flood, believed to be in 1946. The bridge itself, unlike the single arch of the Iron Bridge, was obviously proving a great restriction to the flow of the river, especially when floating debris became wedged under the side arches.

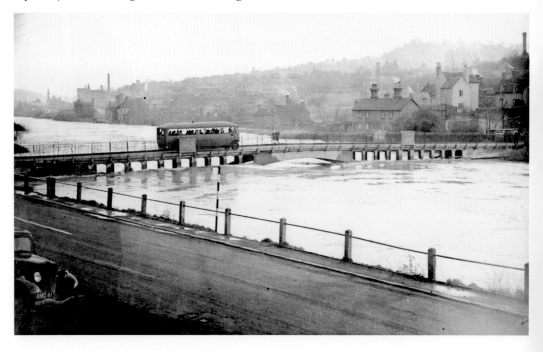

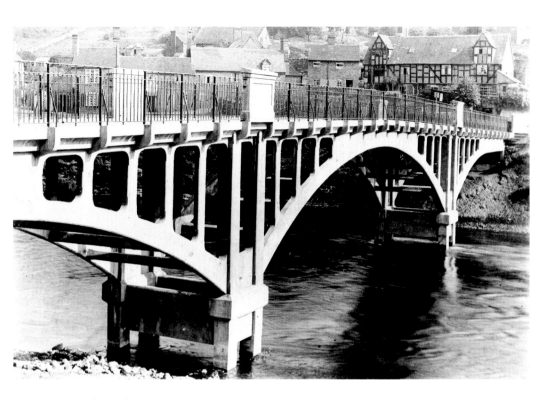

Contrast in Styles

The 1909 bridge was not without some architectural merit, and locals were sorry to see it go. A piece of the original structure is preserved on the Jackfield side. The superb, modern, cable stay replacement Jackfield Bridge, designed after a Public Enquiry had rejected a mundane bridge much closer to the Iron Bridge, is certainly very striking, and locals have become very fond, and proud, of this bridge too.

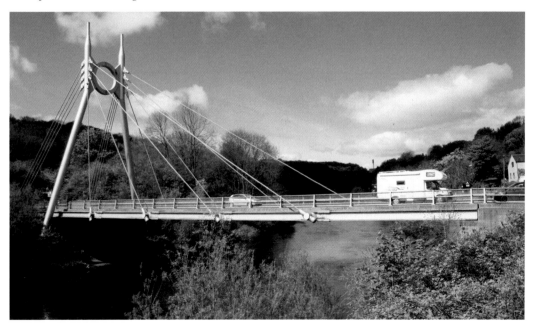

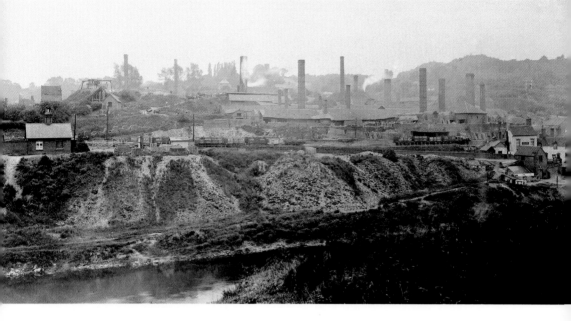

Brick and Tile Industry

Jackfield developed as the centre of the local brick and tile industry, and 'Broseley' tiles became world famous. Several workmen have stopped work to watch the photographer take this picture. Note in particular the antiquated horse gin on the skyline towards the left. On the right is the Black Swan public house, the only feature recognisable in the modern picture, though a lone chimney survives in the trees just beyond. All the others have gone.

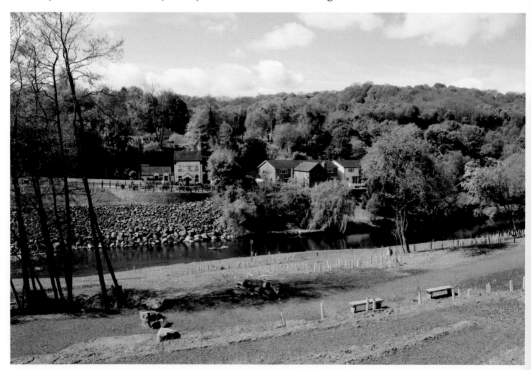

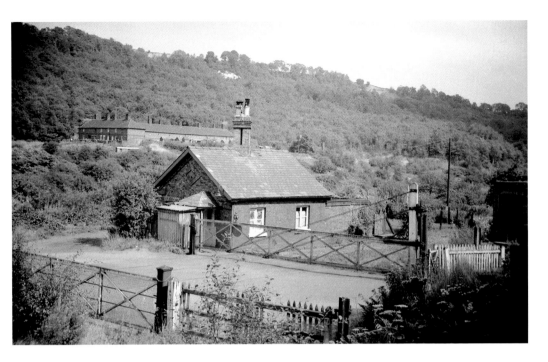

Jackfield Level Crossing
The level crossing near the Black Swan, shortly after the line closed in 1963. The primitive and since-demolished Lloyds Buildings, seen in the distance, are on the north side of the river. The crossing gates have been lovingly restored, together with a non-working signal, some pieces of track and a notice reading 'Jackfield Sidings Middle Ground Frame'. The crossing keeper's cottage was demolished comparatively recently, due to ground subsidence.

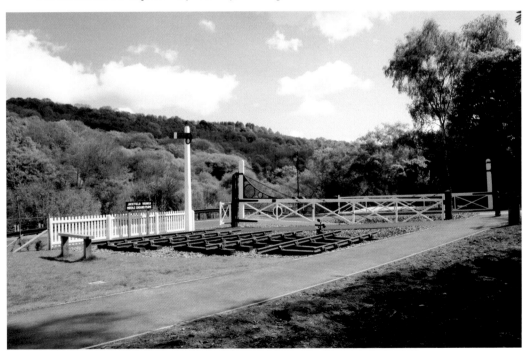

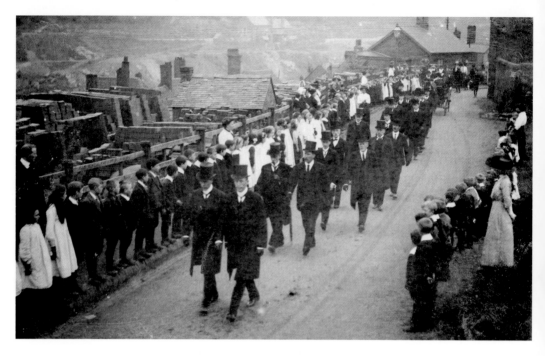

Solemn Occasion

Local schoolchildren have been instructed to line the road to pay their respects as the funeral cortège of the local vicar passes through in 1912. Jackfield School, visible on the right, was built in 1844 and, in 1900, had 250 children on the roll, with an average daily attendance of 214. At the time of writing it is being converted into a private residence. Note all the locally made bricks and tiles beyond the fence, awaiting loading into railway wagons.

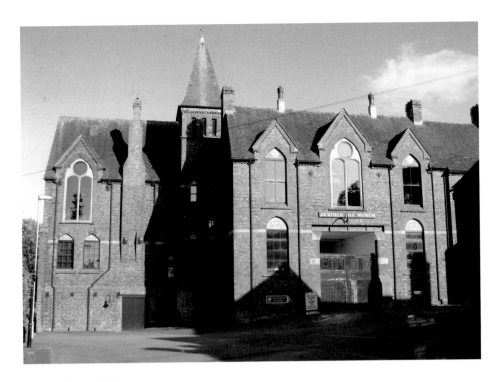

Craven Dunnill Tile Factory

This attractive building now houses the Jackfield Tile Museum. It was built as the Craven Dunnill decorative tile works, and was opened on 25 February 1874. The Severn Valley line, running right alongside, was a factor in the choice of location and was used to despatch the company's products. Note the decorative tile panels above the windows, the larger ones being to let extra light into the drawing offices and showroom.

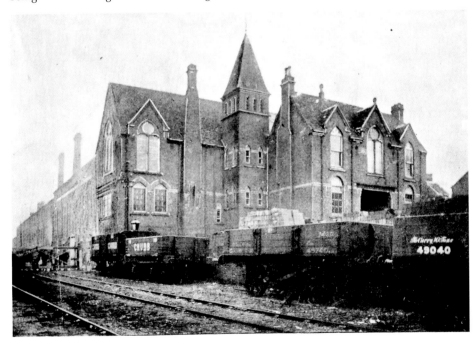

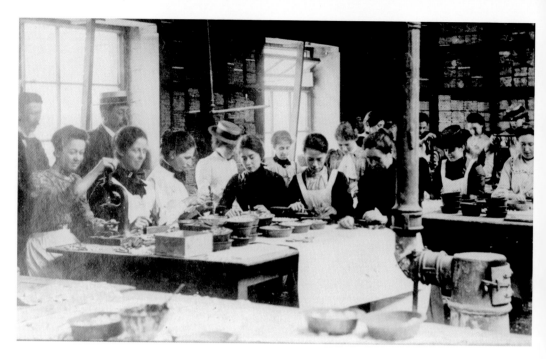

Keeping the Skills Alive

Female workers in the mosaic shop at Craven Dunnill's tile factory, with male colleagues acting as overseers on the left. Craven Dunnill, who share the premises with the museum, have revived their tile making activities, and master craftsman Chris Cox here displays some of the marvellous reproduction encaustic tiles he makes for restoration jobs all over the country and overseas.

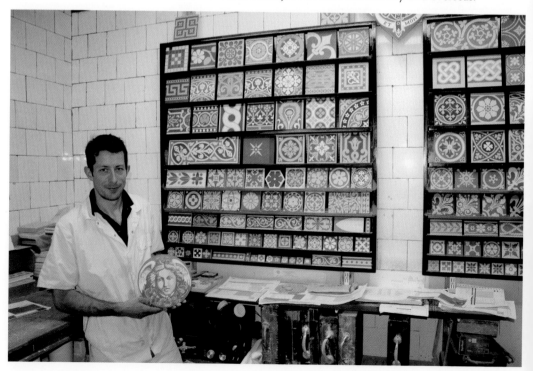

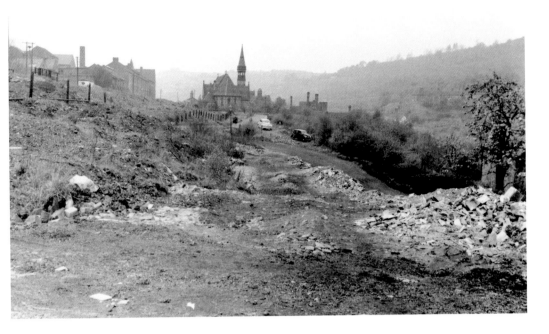

Slipping and Sliding

The Ironbridge Gorge, and Jackfield in particular, have always suffered from subsidence. This photograph shows the aftermath of the major landslip of 1952, which made the national and international news at the time. The road originally ran north of the church, but, following further slips in the 1980s, it was re-routed south of it along the old railway line. St Mary's church, dating from 1863, which is such a superb advertisement for local products, looks sadly in need of repair.

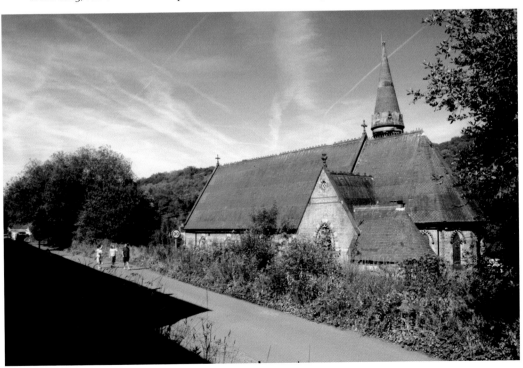

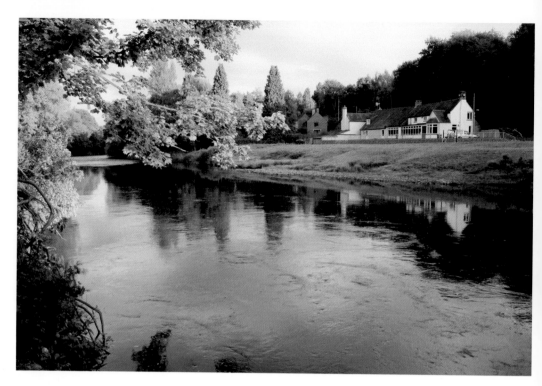

Half Moon

Could there be a greater contrast than these two pictures? The former Half Moon public house and a few other cottages remain. In the earlier picture it can be seen immediately below the tall chimney of Maw & Co.'s tile works. Most of the other structures have since been demolished. Coalport China Works can be seen far left. Note the tile waste, dumped in the river.

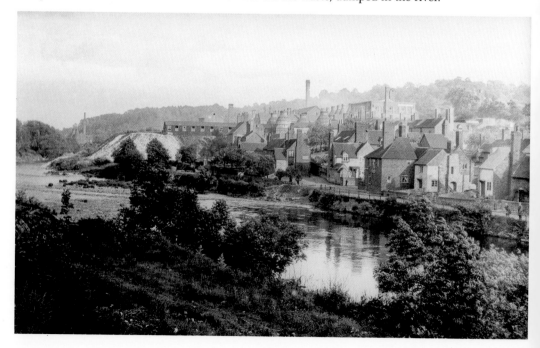

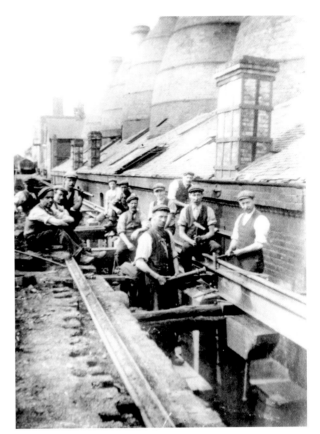

Maw & Company Continued

Maw & Company completed the move from their Benthall Works, near the Iron Bridge, to a massive new factory in Jackfield by 1883, the official opening taking place on 10 May. Workmen are seen repairing the railway line near the kilns, which are the furthermost ones seen in the previous photograph. The impressive entrance façade survives. Confusingly, the factory retained the name Benthall Works, even after the move to Jackfield.

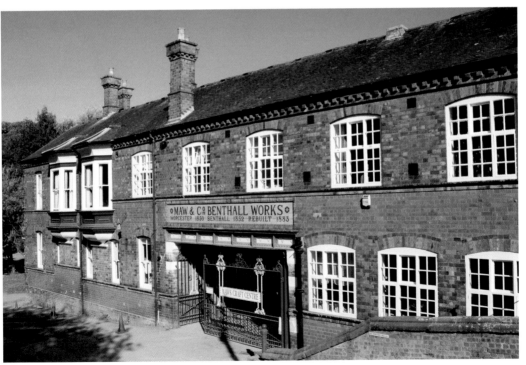

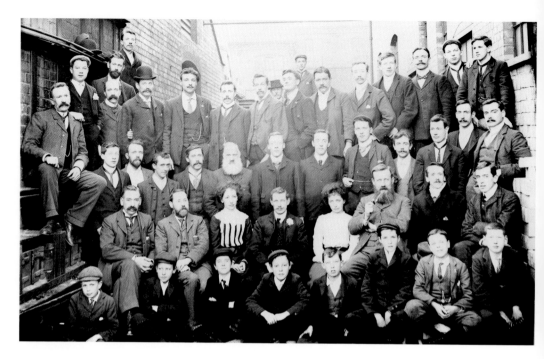

Smile Please!

Everyone looks very serious in this photograph of the Maw & Co. office staff, perhaps because the boss was there (with beard and pipe in his mouth), but in fact the Maw family were known for their harmonious relationship with their workforce. Large parts of the old factory were demolished, but the surviving blocks have been converted into very nice living accommodation and a craft centre.

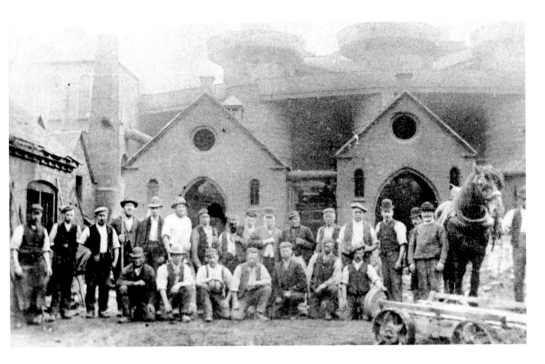

Hard Graft

It was hard graft for these men pictured outside Blists Hill Blast Furnaces. The date is not known, though the furnaces were finally blown out in 1912. Ninety-six years later, it is equally hard graft for the workforce in the reconstructed ironworks at Blists Hill Victorian Town. The event being commemorated was the last shift for retiring ironworks manager, Graham Collis, who is wearing the blue shirt.

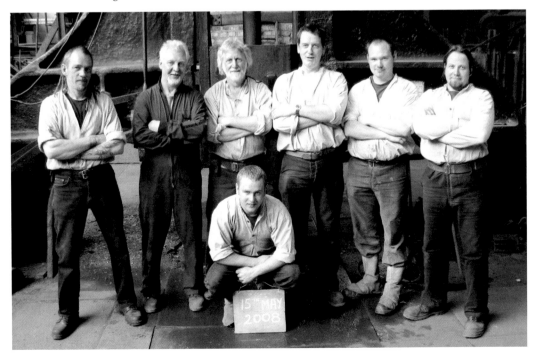

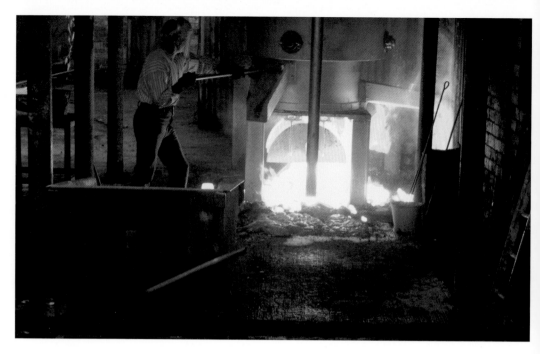

Hot Metal

There's something spellbinding about watching hot metal, as evidenced by this shot of the cupola being emptied at the working foundry at Blists Hill Victorian Town. It's unlikely that the workmen from Oldbury demolishing the old blast furnaces early last century could ever have envisaged such activity returning to the site so many years later, let alone members of the public wanting to come and watch it.

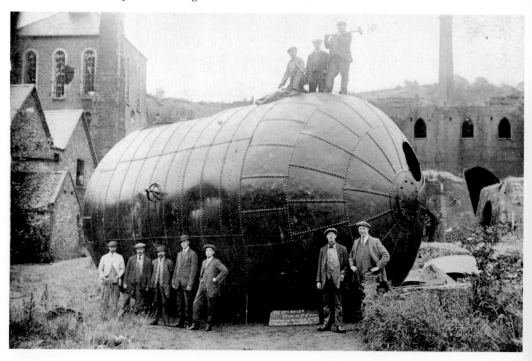

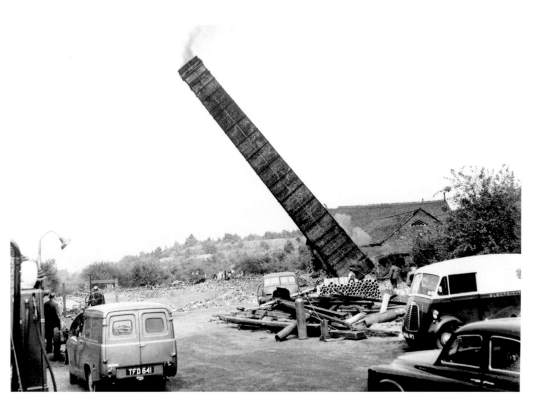

Capturing the Moment

The photographer captured this chimney being demolished at Blists Hill in the 1950s, long before Fred Dibnah made such events popular. Some of the surviving brickworks drying sheds, seen to the right, are now hidden behind Canal Street at Blists Hill Victorian Town. The costumed demonstrators line up for a photograph on the day of the official opening of this new development, 30 April 2009.

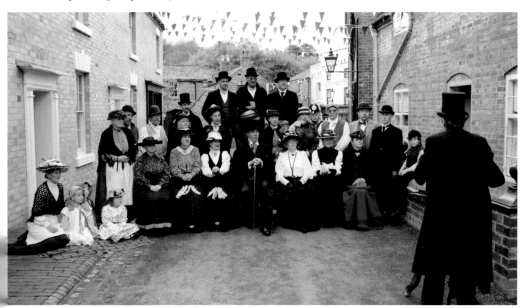

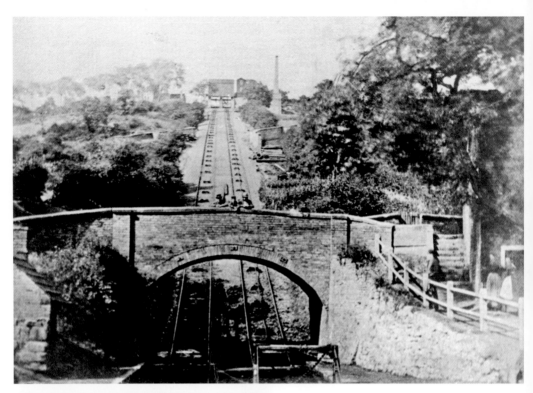

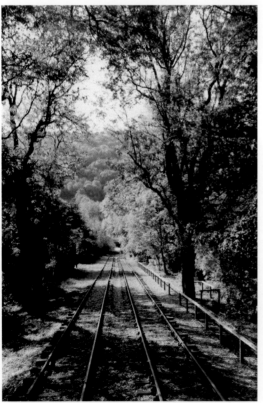

Hay Inclined Plane

View looking up the Hay Inclined Plane, one of several on the East Shropshire canal network. They were preferred to flights of locks, raising and lowering tub boats between different levels on wheeled trolleys, thereby saving both time and water. The photograph is undated, though the inclined plane had fallen into disuse by about 1894. The modern view was taken from inside the Blists Hill site, looking down the incline in the autumn of 1991.

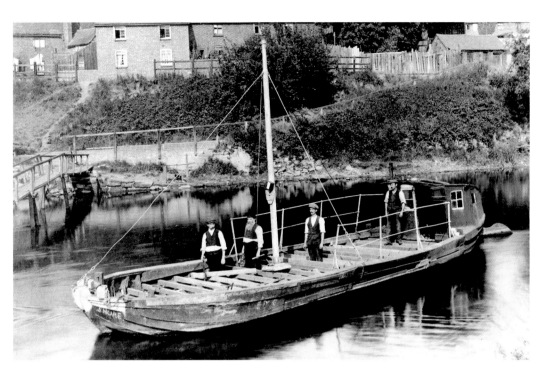

Coalport Ferry

A ferry boat formerly operated at the foot of the Hay Inclined Plane, seen here having its deck repaired. Things look calm enough here, but one disastrous night in 1799, the ferry overturned and twenty-eight workers from the Coalport China Works were swept away to their deaths. The buildings in the background are instantly recognisable today, though the sloping path down to the ferry and the brickwork have either disappeared or are hidden by the undergrowth.

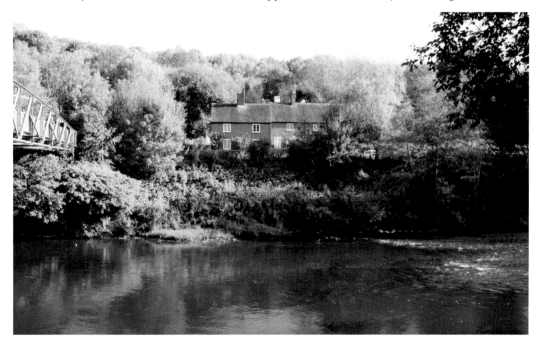

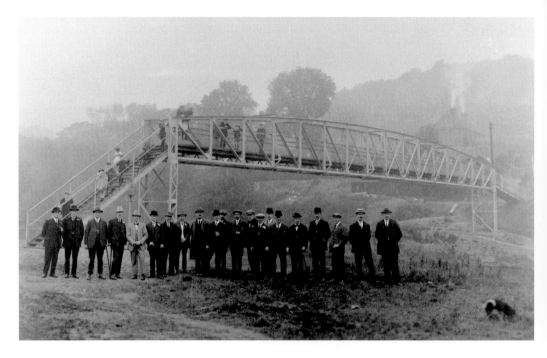

Jackfield Memorial Footbridge

A footbridge was erected linking Coalport and Jackfield in 1922. Unusually, it not only replaced the ferry, but was also dedicated as a war memorial, recording the names of those who lost their lives in the Great War. By 2000 it needed repair and was taken away for 'refurbishment', though what came back was effectively a completely new bridge. It is seen here being officially re-opened by Lord and Lady Forester on 15 July of that year.

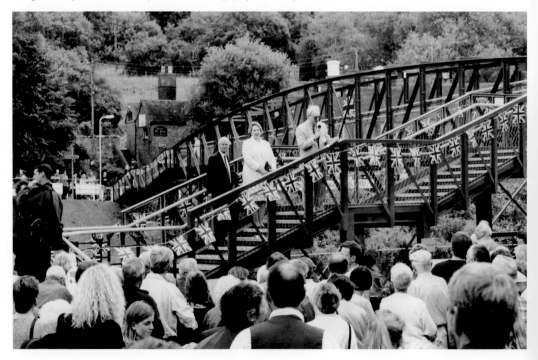

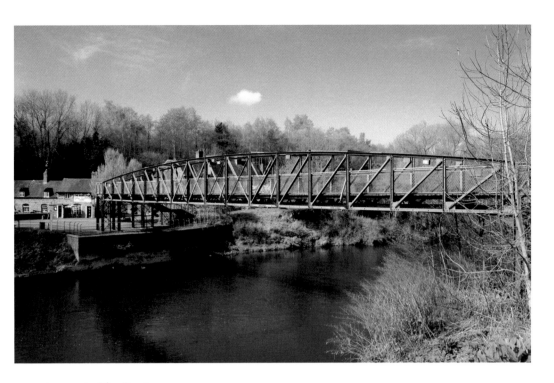

Across to The Boat

The bridge leads across from the Coalport side towards the Boat public house, well known locally for its live music and other community-based events. The walls of the pub are marked with various flood levels, and although just out of shot, it would certainly have been inundated during this serious flood of 1 March 1923. The enormous size of Maw & Co.'s works, nearly three times the size of Craven Dunnill's factory, is very apparent.

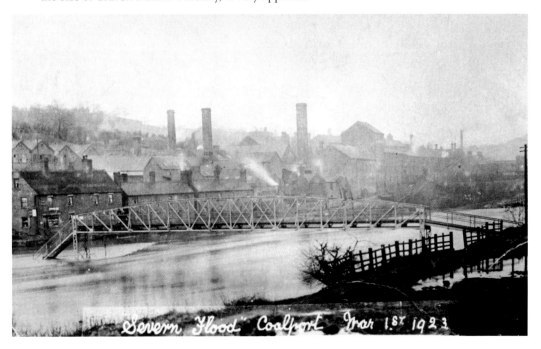

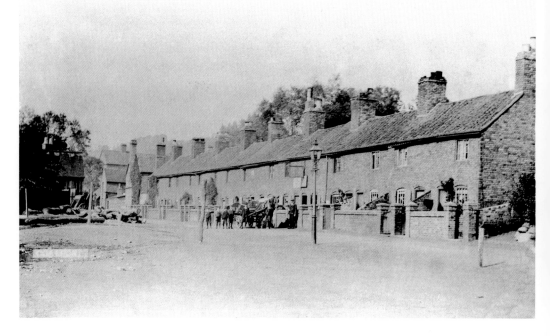

Jug Row

Just east of the Hay Inclined Plane stood Jug Row, a long row of cottages occupied by workers at the nearby Coalport China Works. They have long since been demolished, though the Shakespeare Inn at the far end survives, its customers now utilising the site of the cottages as a car park.

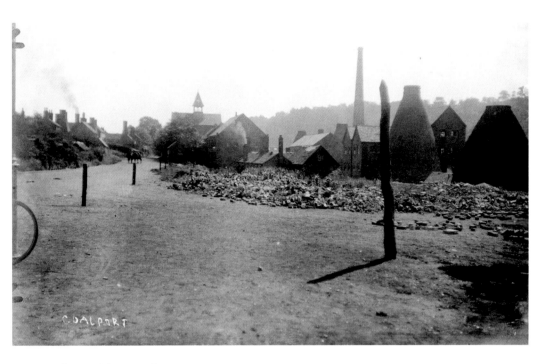

Coalport China Works

View looking south-east across Coalport China Works, the scruffy appearance of which forms a marked contrast to the delicate products manufactured there. As at the tile works, there was much waste simply thrown into the river. The tall chimney, like the one by the Iron Bridge, succumbed to lightning and was demolished in the 1930s, and some other buildings seen here have since disappeared. Today greenery hides much of the site from the road.

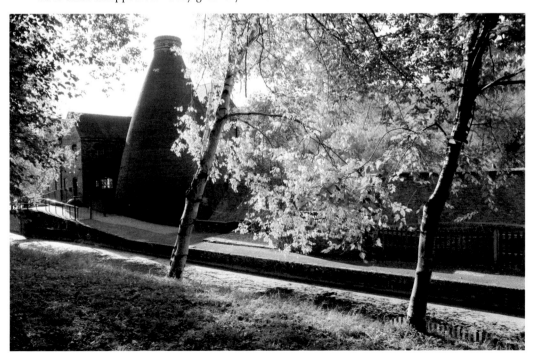

87

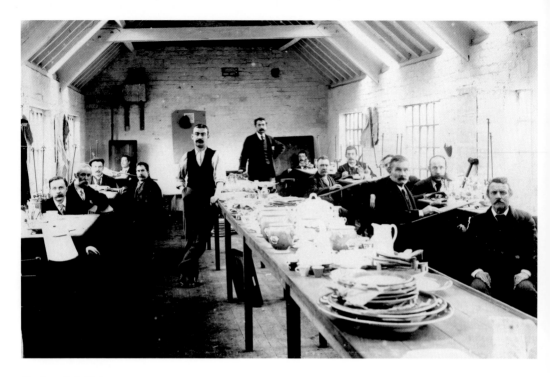

Coalport Artists

This photograph of artists at the Coalport Works was sent back from Canada by the son of one of the men shown, who had emigrated when the works closed down in 1926. Volunteer Ken Jones shows visitors round the surviving workshops, which now form part of the Coalport China Museum, in June 1993. Lighting was minimal, the workforce making as much use as they could of natural light coming in through the large windows.

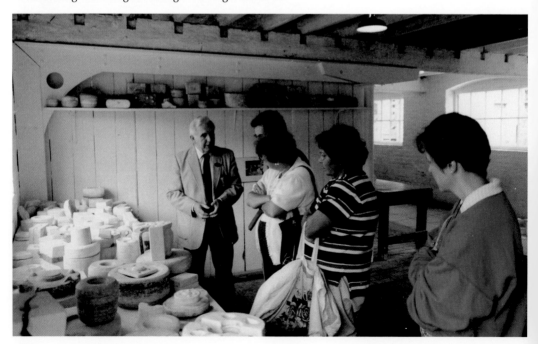

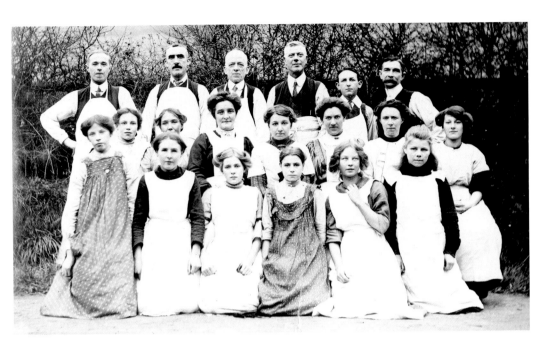

Women Workers

Although the well-known artists were almost exclusively men, large numbers of the workforce at Coalport were women, many of them young girls who were expected to leave once they got married. They performed various intricate tasks, such as gilding, burnishing, and the application of transfers. The skills of china painting and flower making are today kept alive by demonstrators at the museum, including Kate Cadman, who is seen here explaining the techniques to a visitor.

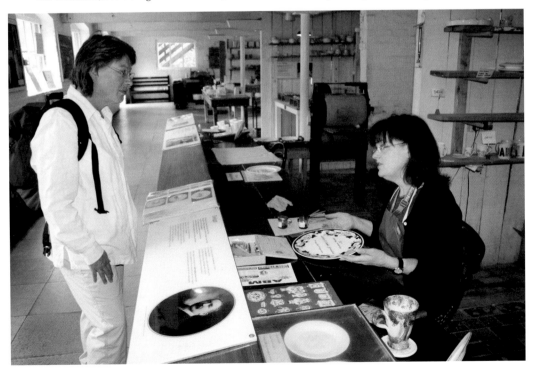

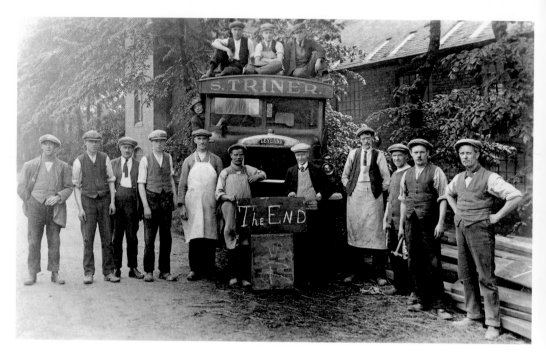

'The End'

The end came at Coalport in 1926, when the firm was taken over and manufacture transferred to Stoke on Trent. Those who wanted it were offered a bus service to Stoke daily, but this became irksome, and workers either moved to Stoke or sought work elsewhere. These surviving parts of the works adjacent to the museum house the Coalport Youth Hostel and Enterprise HQ, whilst one or two other nearby buildings have been converted into housing.

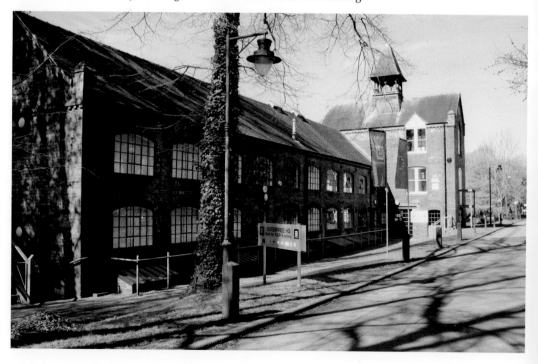

Last Trow

This staged photograph opposite Coalport China Works was sold as a postcard, claiming that it showed the last trow on the River Severn, though research has revealed that the last boat was in fact named *Harry*, not *William*. Nowadays, views of the works from the other side of the river can only be enjoyed in the winter months, when there are no leaves on the trees.

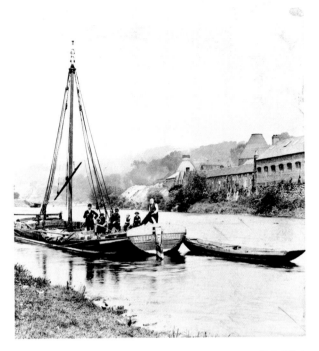

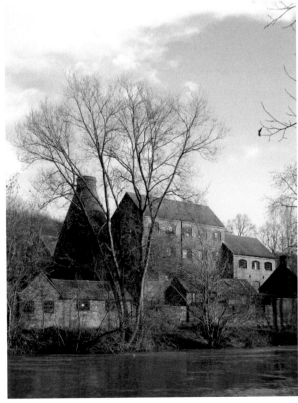

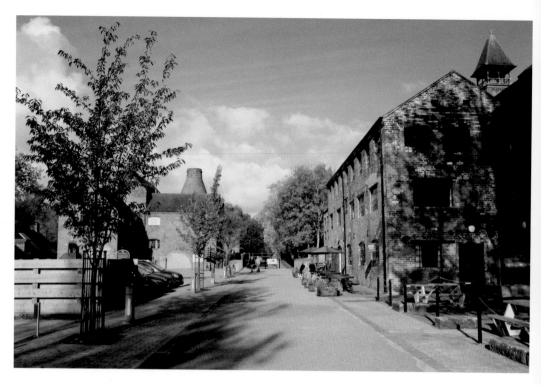

Canal at Coalport

Although not in water, the line of the former Shropshire Canal has been retained beyond the museum site, into the recent housing development known as Reynolds Wharf. The canal formerly extended from the foot of the Hay Inclined Plane right through Coalport China Works towards a large warehouse and terminus near Coalport Bridge. There was never any physical connection with the River Severn, goods being transhipped across wharves.

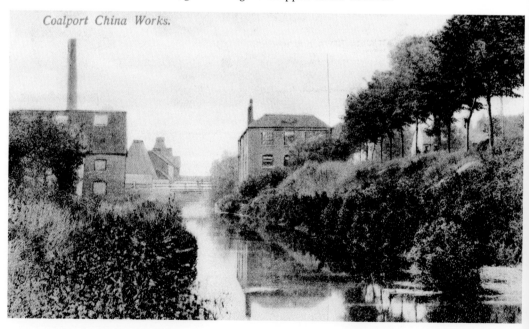

Coalport China Works.

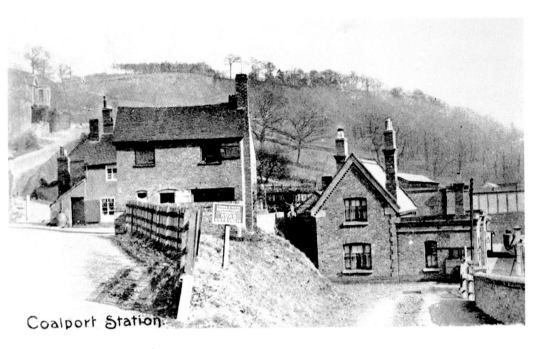

Coalport Station.

Coalport LNWR Station

Coalport enjoyed the luxury of two railway stations. The one on the north side of the river was a London and North Western Railway station, opened to passengers in 1861. Its closure cannot be blamed on Dr Beeching, as lack of use caused it to lose its passenger service as early as 1952. The trackbed is now a scenic footpath and cycle track, known as the Silkin Way, which stretches all the way to Telford Town Centre and beyond.

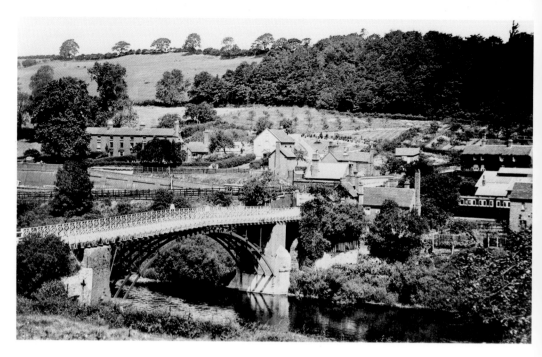

Coalport Bridge

Somewhat overshadowed by its more illustrious neighbour upstream, Coalport Bridge nevertheless has an interesting history of its own. As the nearby Woodbridge public house indicates, it was originally made of wood and later rebuilt in iron. Like the Iron Bridge, it was once a toll bridge, and the tollhouse survives at the north end. Unlike the Iron Bridge, which has been spared road traffic since 1934, Coalport suffers from an excess of traffic, especially during the rush hour.

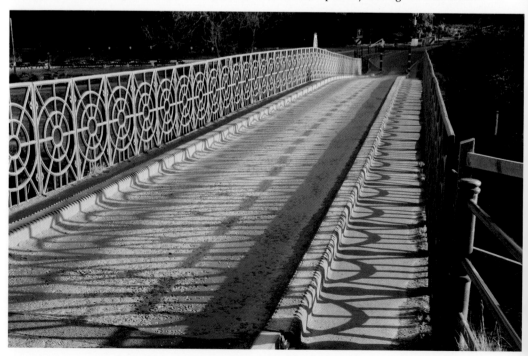

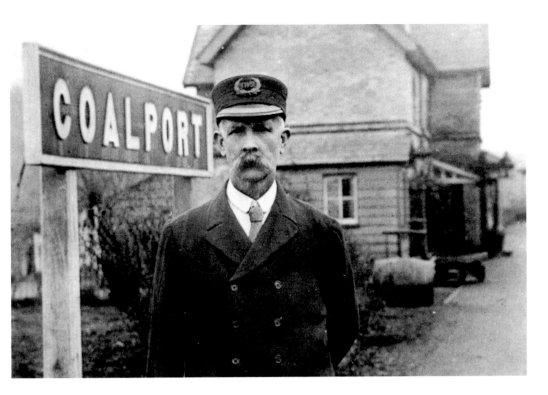

Coalport GWR Station

South of the river, the former Great Western Railway Station is on the same line as Ironbridge and Broseley, and closed to passengers on the same day in September 1963. The stationmaster sixty years earlier could never have dreamt of this ever happening. Happily, the station building has survived, and it is now possible to re-live something of the past by holidaying in an old railway coach at the station platform.

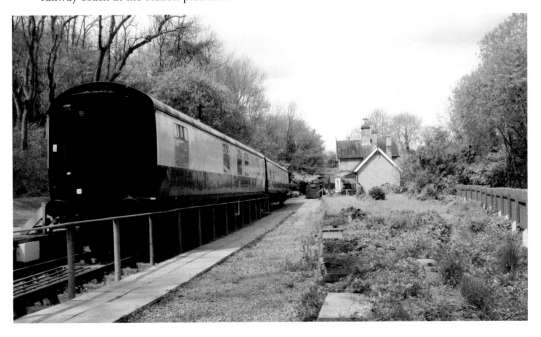

Acknowledgements

The author would like to convey his thanks to the following friends and colleagues, some since deceased, who have discussed the historic photographs in this volume with him over the years:

Judith Alfrey, Trevor Bagley, Keith Beddoes, Paul Belford, Marion Blockley, Terry Blud, Ivor Brown, Tony Carr, John Challen, Kate Clark, Neil Clarke, Paul Collins, Jim Cooper, Neil Cossons, Ruth Crofts, Michael Darby, Margaret and Maurice Darlington, David de Haan, Ruth Denison, Harriet Devlin, Steve Dewhurst, Traci Dix-Williams, Janet Doody, Betty Duddell, Ken and Margaret Fowler, George Gilbert, Harold Grice, Richard Hayman, Tony Herbert, Graham Hickman, David Higgins, Marilyn Higson, Oliver Holmes, Wendy Horton, Rachel Iliffe, Ken Jones, John Malam, Cath and Jack Marshall, Ron Miles, Brian Pitchford, Eustace Rogers, Joanne Smith, Stuart Smith, Dianna Stiff, Michael Stratton, Emyr Thomas, Barrie Trinder, Michael Vanns, Mel Weatherley, Fred Williams, Sylvia Williams, Maurice Woolley and Michael Worthington.

Apologies to anyone who may have been inadvertently omitted. Thanks are due to photographer David Houlston, not only for his careful handling of the museum's precious photographs, but also for some of the helpful tips he has given to the author. Extra thanks also to Joanne Smith for doing all the scanning and supporting the project enthusiastically from the outset.

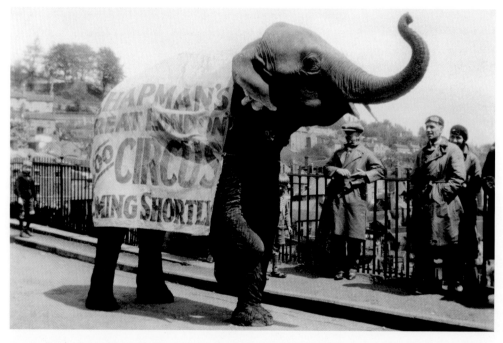

An elephant advertising a forthcoming circus causes great excitement as it crosses the Iron Bridge.